Will Daniel

Delaware River Reflections

Schiffer Publishing Ltd®

4880 Lower Valley Road • Atglen, PA 19310

Library of Congress Control Number: 2016955281

Designed by Danielle D. Farmer
Cover design by RoS
Type set in ITC Zapf Chancery/ApolloM I/Benton Sans

ISBN: 978-0-7643-5229-4
Printed in China

Published by Schiffer Publishing, Ltd.
4880 Lower Valley Road
Atglen, PA 19310
Phone: (610) 593-1777; Fax: (610) 593-2002
E-mail: Info@schifferbooks.com
Web: www.schifferbooks.com

For our complete selection of fine books on this and related subjects, please visit our website at www.schifferbooks.com. You may also write for a free catalog.

Schiffer Publishing's titles are available at special discounts for bulk purchases for sales promotions or premiums. Special editions, including personalized covers, corporate imprints, and excerpts, can be created in large quantities for special needs. For more information, contact the publisher.

We are always looking for people to write books on new and related subjects. If you have an idea for a book, please contact us at proposals@schifferbooks.com.

Other Schiffer Books by Will Daniel:
James River Reflections, ISBN 978-0-7643-3727-7
My Virginia Rivers, ISBN 978-0-7643-4325-4

Other Schiffer Books on Related Subjects:
The Illustrated Delaware River: The History of a Great American River, Hal Taylor, ISBN 978-0-7643-4932-4

For Michelle Daniel Garrido
1969–2015

LOVING AND BELOVED DAUGHTER, SORELY MISSED.

I wish this book could hold the hundreds of photos I have of you standing on the banks of the river. These words will have to do, so rest in peace, sweet daughter.

For Tom Beitz
1953–2013

LIFELONG FRIEND AND PHOTO COMPANION.

You provided inspiration for this book, and you were supposed to be my coauthor. You went to the great photo studio in the sky way too soon, so I did it myself.

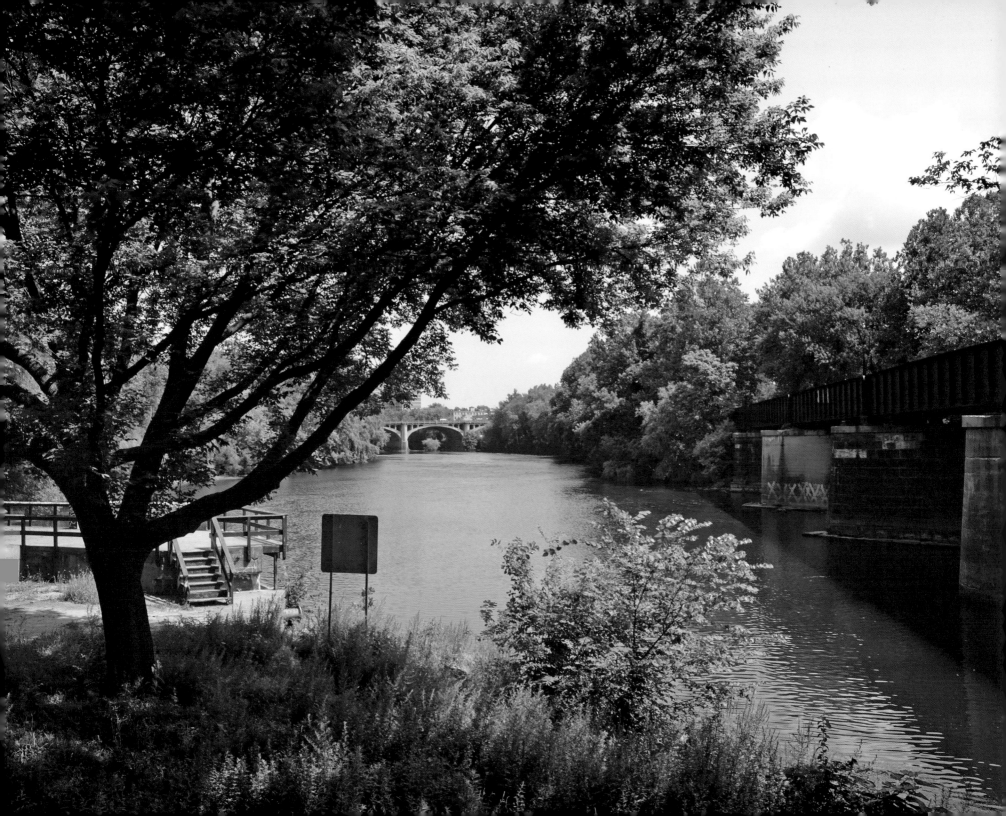

Contents

6 — *Foreword*
BY MAYA K. VAN ROSSUM, the Delaware Riverkeeper

8 — *Acknowledgments*

9 — *Introduction*
AN OLD LOVE AND A NEW ADVENTURE

16 — *Delaware River Basin*

24 — *Upper Delaware, Where It Begins—*
HANCOCK, NEW YORK, TO THE DELAWARE WATER GAP

43 — *Delaware Water Gap National Recreation Area*

52 — *Delaware Water Gap to Easton and Phillipsburg*

65 — *Phillipsburg to Trenton*

82 — *Bucks County, Pennsylvania, and Burlington County, New Jersey*

91 — *Philadelphia and Southeastern Pennsylvania*

98 — *Wilmington, Northern Delaware, and Southern New Jersey*

110 — *Delaware Bay*

119 — *The Tributaries*

136 — *Tips for Photographers*

143 — *Bibliography*

Foreword

BY **MAYA K. VAN ROSSUM,**
the Delaware Riverkeeper

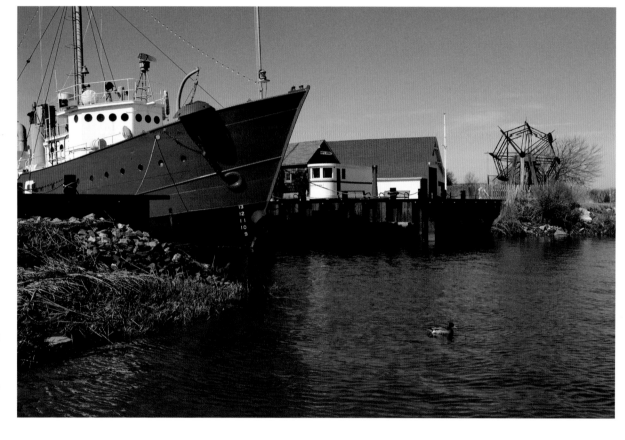

Historic Lewes, Delaware, is home of the lightship *Overfalls*, one of only seventeen remaining lightships of 179 built from 1820 to 1952. Designated a National Historic Landmark in 2011, it is one of seven lightships in this country still open to the public.

In 1931, Supreme Court Justice Oliver Wendell Holmes wrote famously about the Delaware River, "A river is more than an amenity, it is a treasure."

Holmes is often quoted by those seeking to impress on others the importance of the Delaware River. The sentiment is certainly beautiful, but there is more to what he wrote: "It offers a necessity of life that must be rationed among those who have power over it."

Suddenly the meaning of the quote is transformed: "A river is more than an amenity, it is a treasure. It offers a necessity of life that must be rationed among those who have power over it."

The full text reflects a view that, sadly, is held by many: that our river is not to be treasured as a living, breathing, evolving member of our community to be respected and protected. Instead, the river is a servant, required to do its master's bidding regardless of the harm inflicted on it.

When we think we have power over the Delaware River, when we think it is here to serve us, when we think it is ours to harness and ration among our communities, that is when the damage is done to both the river and to ourselves, in both the short term and the long term.

Access to pure, life-sustaining water that supports diverse and healthy aquatic communities is an inalienable right of all beings. We do not have the right to ration the river purely to serve human communities, nor do we have the right to ration it to serve one human community at the expense of others—e.g., for industry to the detriment of drinking water. We have an obligation to fully protect the Delaware River and all its natural elements for the benefit of all communities, both human and wild.

There was a time in the mid-twentieth century when we used the Delaware as a mere servant—to provide drinking water, to wash away our wastewater, to serve the growing demands of industrial operations, and to give up unsustainable yields of fish and crabs. At the same time, we deforested and over-developed the river's watershed, introducing new pollution and harms.

Under the burden of our demands, the Delaware became polluted and its aquatic life severely diminished. The river's water was unsafe to drink without extensive treatment. Dockworkers got sick from contact with the water. Recreation was seriously compromised. The fish that had supported successful fisheries (commercial and recreation) began to disappear. Even industry was adversely affected by the contaminated waters. The Delaware had become so polluted that it prevented the upriver migration and spawning of the historically and ecologically important American shad.

The Delaware River might have stayed that way, but people who respected and cared for our river would not have it—they got vocal and active in their efforts to save the Delaware. Nationally, laws were passed responding to the degradation of the Delaware and other environments. And restoration of the Delaware River's water quality, ecosystems, and keystone species like shad was made possible.

A clean, healthy, and free-flowing Delaware River provides the greatest level of protection, healthy growth, and quality of life to our communities. Today the Delaware River provides drinking water to more than seventeen million people and supports over $22 billion of economic benefit to our region annually.

But the job of protecting the Delaware River and restoring it to health is far from done. New threats emerge almost daily—shale gas extraction including drilling and fracking,

fracked gas pipelines and processing plants, continued floodplain development, ongoing and new pollution inputs and massive water withdrawals, and the continued unsustainable take of species.

To be healthy, our Delaware River—including its floodplains, flows, tributaries, aquifers, and habitats—needs respect, protection, and restoration as much today as it did fifty years ago.

As you read this book and enjoy its beautiful pictures, I hope the beauty and power of our Delaware River will inspire you to rise up and protect our river and its beautiful tributaries, as well as the one that flows through your community.

Acknowledgments

My old friend Bing Gary. His expert knowledge of Phillipsburg, New Jersey; Easton, Pennsylvania; and the canals of the area, plus the Catskill Mountains, added richness to this book.

Maya K. van Rossum, the Delaware Riverkeeper. Her insightful foreword provides valuable background information for the book, and her organization's status as the premier advocacy organization gives hope for the river's continued success in terms of environmental health.

Author Ann Woodlief. She gave me words to describe how overwhelming it can be to witness a river's majesty while trying to capture its beauty with a camera.

Longtime friends and colleagues Brett Turner, Ken Yavit, and Susan Barone. Best proofreaders ever.

Lisa Ferri and the communications staff of Comcast. They allowed me to photograph Philadelphia and the Delaware River from the forty-third floor of Comcast Center.

Introduction

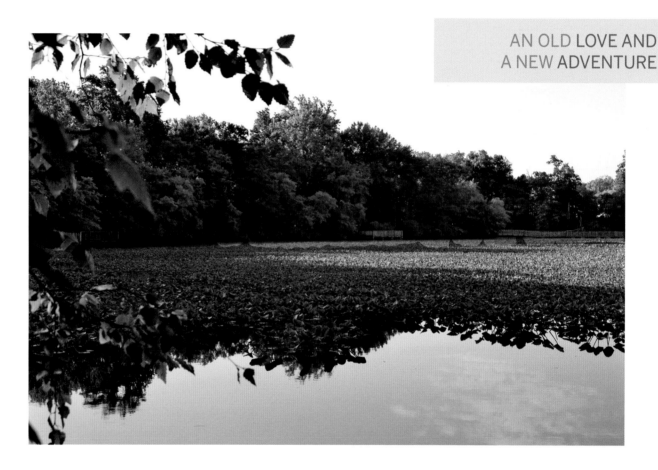

Aquatic plant life covers the peaceful Rancocas Creek at Mill Dam Park, Mount Holly, New Jersey.

I've loved the Delaware River since 1961, when I walked across the Burlington-Bristol Bridge from the New Jersey side into Pennsylvania, a distance of nearly a half-mile, and sixty-one feet above the water at high tide. Only from that pedestrian perspective could a kid who was too young to drive and had recently moved into the area appreciate the full scope of this powerful river at that point just a few miles north of Philadelphia.

Later, my wife Sharon and I lived within walking distance of the river in Delanco, New Jersey, near the confluence of the Delaware and my beloved Rancocas Creek, known as Rancocas

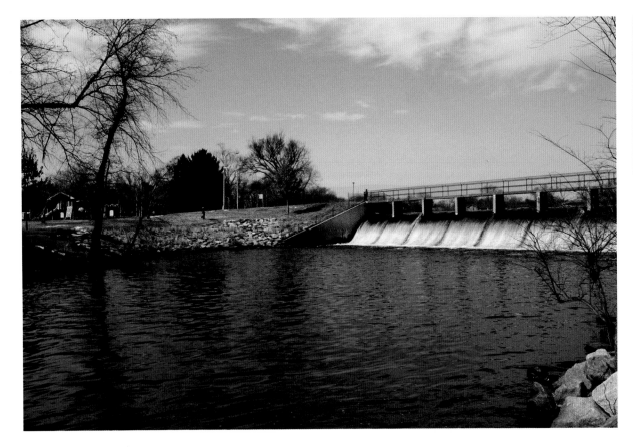

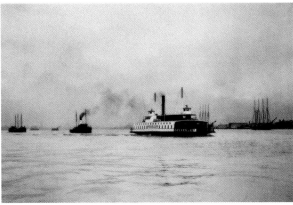

Coal barges in tow on the Delaware River c. 1901.
Photo by Louis Husson, courtesy Library of Congress.

The Silver Lake Reservoir flows into St. Jones
River over this dam at Dover, Delaware.

River in a bygone era. We took many walks along the Delaware and the Rancocas with our young child, Michelle, in a stroller, and bicycle rides with her strapped into a seat on the back of our tandem. The Rancocas was a favorite swimming location for my friends and me during our high school years. We had access to private property in a sleepy little part of Eastampton Township, New Jersey, called Ewansville. Read more about the Rancocas Creek in the tributaries chapter starting on page 119.

One of our fondest memories as a young married couple was camping near a place that is part of the famous Delaware Water Gap called Sunfish Pond, which overlooks the Delaware River a thousand feet below. I had camped there earlier with my photographer pal, the late Tom Beitz. More information about the Delaware Water Gap National Recreation Area begins on page 43.

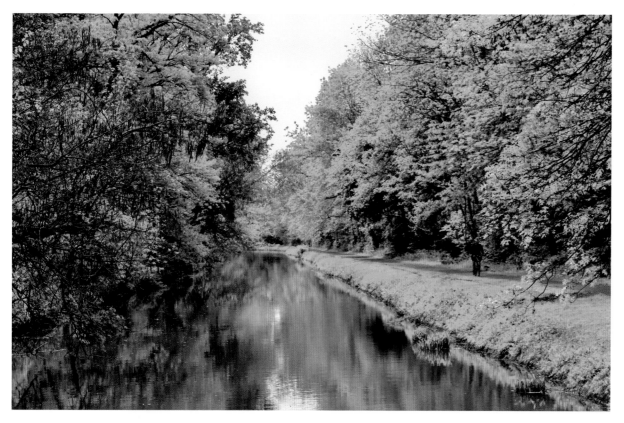

The banks of the scenic Delaware and Raritan Canal provide a peaceful walking path at Titusville, New Jersey.

The *North Star* dredges the Delaware River at Burlington, New Jersey, near the Burlington-Bristol Bridge.

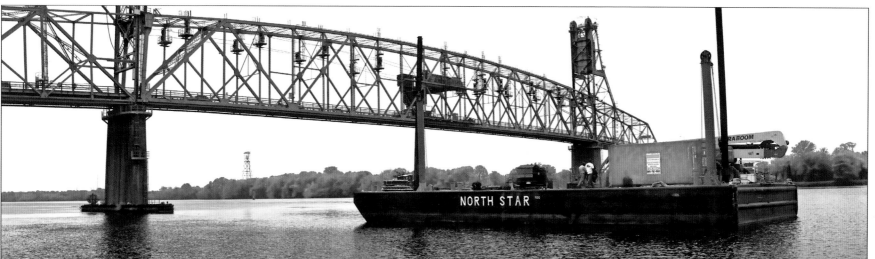

Bertolet Fishing Dock on the Schuylkill River at West Reading, Pennsylvania. The Schuylkill is a major tributary of the Delaware.

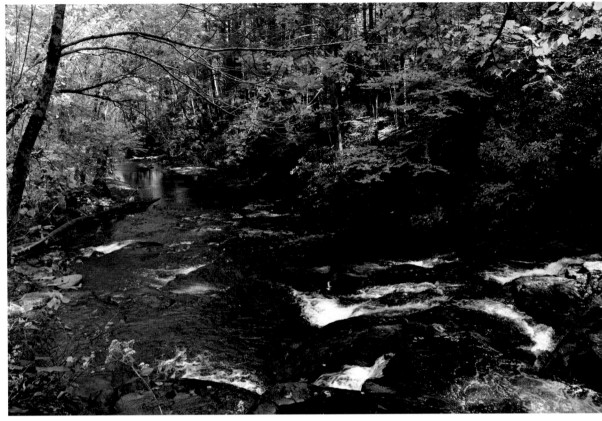

Dingmans Creek is a picturesque tributary of the Delaware River in Delaware Water Gap National Recreation Area.

So, you could say the Delaware River and its beautiful tributaries were a big part of my teenage years and early adult life. Every time I crossed the Delaware Memorial Bridge between Southern New Jersey and Delaware, I was awestruck by the sheer magnitude of this magnificent flowing water.

After I published my first book of riverscape photographs, I told my brother that I could write a book about writing the book. My never-ending pursuit of beautiful river photos brought one adventure after another and provided just the right narrative to accompany them. Photographing the Delaware River from its beginning at the confluence of the East and West branches in Hancock, New York, to the point where the Delaware Bay meets the Atlantic Ocean has been yet another exciting adventure.

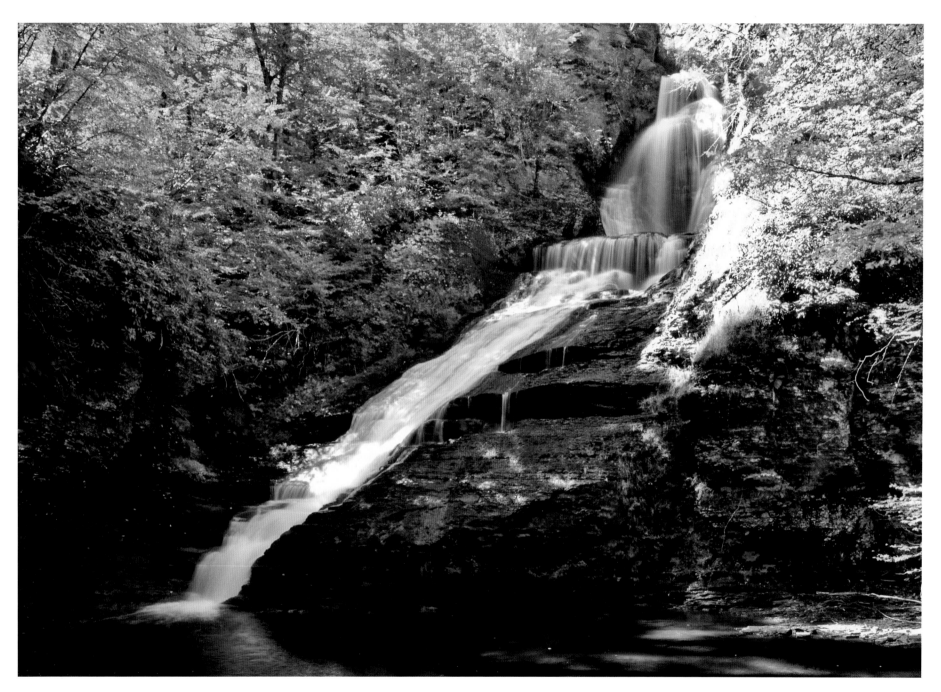

Dingmans Falls is one of the most spectacular attractions in
the Delaware Water Gap National Recreation Area.

This scenic bend in the Delaware River was photographed at Lackawaxen, Pennsylvania. New York is on the other side.

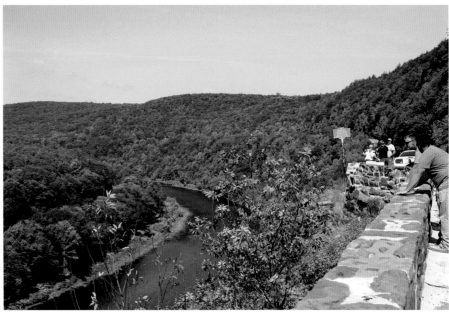

New York Route 97, the state's Scenic Byway, offers spectacular views like this one of the Delaware River.

But sometimes words just can't describe the beauty that a photographer sees. In her book *In River Time: The Way of the James*, author Ann Woodlief writes that photographs "fall short of depicting the truth of rivers, for they must halt and distort, especially when they try to capture the river's motion. I know of a few persons who understand this, who have become so entranced with the truths spoken by the river that they abandoned both cameras and language to sit beside the river in silence, day after day" (Woodlief 1985, 4).

When I was working on my first book, *James River Reflections,* I contacted Woodlief and told her that she now knows one more photographer who understands this phenomenon. It happened to me repeatedly as I worked on that first book, and it continued as I worked on *My Virginia Rivers,* and now this one, especially in the wondrous Delaware Water Gap National Recreation Area and along the scenic byways of Pennsylvania and upstate New York. It will likely affect me the rest of my life, and for that I will be eternally grateful.

This book holds special meaning for me because of my deep connection to the Delaware River from an early age. Thank you for allowing me to share my adventures with you and my enthusiasm for this vital water source. I hope reading this book will help you understand the necessity of protecting this beautiful natural resource.

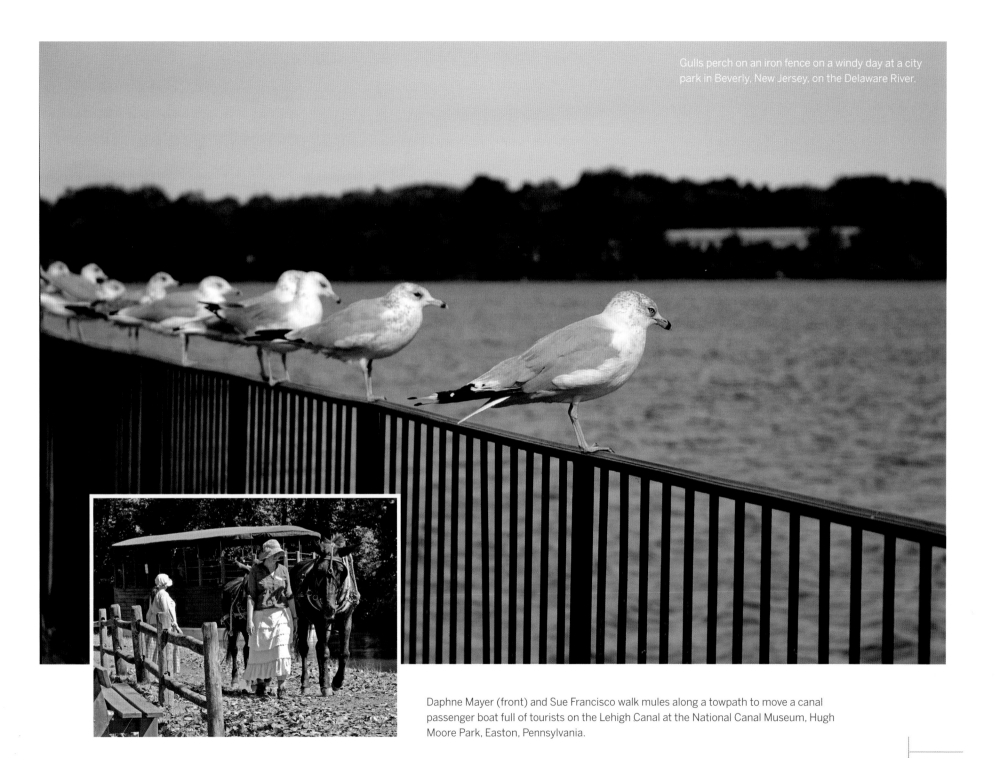

Gulls perch on an iron fence on a windy day at a city park in Beverly, New Jersey, on the Delaware River.

Daphne Mayer (front) and Sue Francisco walk mules along a towpath to move a canal passenger boat full of tourists on the Lehigh Canal at the National Canal Museum, Hugh Moore Park, Easton, Pennsylvania.

Delaware River Basin

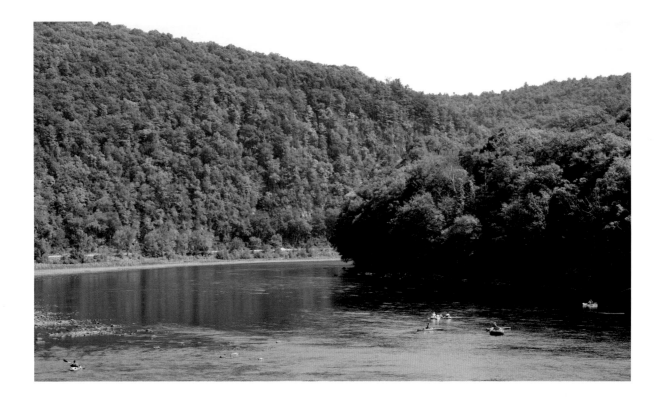

At Lumberland, New York, visitors are treated to this scenic view of the Delaware River.

The Delaware River, named for Thomas West III, twelfth Baron De La Warr (1576–1618), flows undammed for 330 miles from its beginning in New York's Catskill Mountains through Pennsylvania, New Jersey, and Delaware before it reaches the Atlantic Ocean. On its way, it flows through more than 13,000 square miles of rural and urban landscapes, and 800 square miles of the Delaware Bay. Throughout its journey, the river is a boundary between two states: first New York and Pennsylvania, then Pennsylvania and New Jersey, and finally New Jersey and Delaware. The basin contains more than 2,000 tributaries, some of which are major rivers discussed elsewhere in this book.

According to the Delaware Riverkeeper Network website, fifteen million people—about five percent of the nation's population—rely on the Delaware River Basin for their drinking water. This includes the cities of New York and Philadelphia (www.delawareriverkeeper.org/).

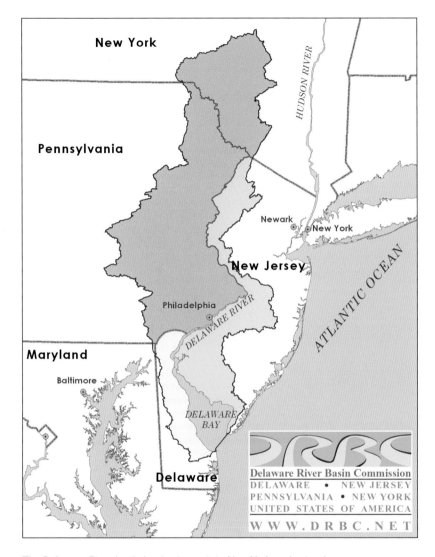

The Delaware River basin begins in upstate New York and extends to the Delaware Bay and the Atlantic Ocean at Cape May, New Jersey. *Map outlining the Delaware River Basin, courtesy of the Delaware River Basin Commission (www.drbc.net).*

Mill Dam Park at Mount Holly, New Jersey, along the Rancocas Creek has been a favorite recreation site of residents for more than a century.

Nearly a thousand community water systems depend on the water resources of the Delaware. The basin provides domestic drinking water, recreation, fisheries and wildlife, energy, industry, and navigation. Land uses in the watershed are diverse and include forests, agriculture, and urban landscapes. Those land uses, and influences such as climate and population growth, affect the quality and quantity of the basin's water resources today, and will continue to do so in the future (www.delawarebasindrinkingwater.org/).

The estuary, or place where river water meets ocean water, at the southern end of the river includes the world's largest horseshoe crab population. Up to seventy percent of the oil shipped to the Eastern Seaboard of the United States moves through this estuary. The Delaware River Port Complex, which includes facilities in New Jersey, Pennsylvania, and Delaware, comprises the largest freshwater port in the world.

According to the Delaware River Basin Source Water Collaborative, the river officially begins at Hancock, New York, where the East Branch Delaware River and West Branch Delaware River meet. Its tributaries

This is the view from Sandt's Eddy boat ramp on Route 611 a few miles north of Easton, Pennsylvania. Harmony Township, New Jersey, is on the other side. Route 611 in this area is one of Pennsylvania's designated Scenic Byways.

The Schuylkill River flows at the bottom of a long path from Klapperphall Road, Reading, Pennsylvania.

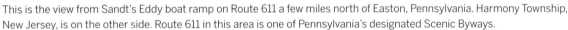

originate in the Catskill Mountains at elevations of up to 4,000 feet. From that confluence at Hancock, the Delaware gradually drops approximately 800 feet until it hits sea level, where it meets the Atlantic Ocean after flowing through the massive Delaware Bay.

The drainage area covers large land areas in the four states it flows through: New York, New Jersey, Pennsylvania, and Delaware. People in more than 800 municipalities within those states benefit from the water resources of the Delaware River Basin, and water is also exported to cities in New Jersey and New York outside the basin boundary. Almost nine billion gallons of Delaware River Basin water are used each day, including about half a billion gallons exported to New York City and large cities in northeastern New Jersey (www.delawarebasindrinkingwater.org).

Commerce was important on the river's many canal systems before 1857, when railway competition made them unnecessary. According to Princeton University scholars, the Delaware Division of the Pennsylvania Canal, which ran parallel with the river from Easton to Bristol, Pennsylvania, opened in 1830. The Delaware and Raritan Canal, which ran along the New Jersey side of the Delaware River from Milford to Trenton, emptied the waters of the Delaware River via the canal outlet into the Raritan River at New Brunswick, New Jersey. New Jersey still uses this canal water conduit as a water supply. The Morris

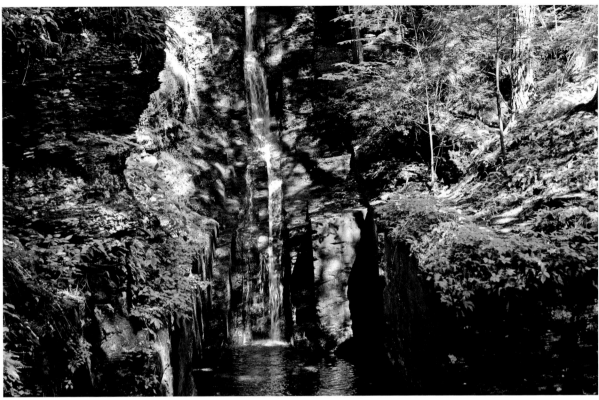

Silverthread Falls spills into Dingmans Creek, a tributary of the Delaware River in Delaware Water Gap National Recreation Area.

Canal, now abandoned and almost completely filled in, connected the Delaware and Hudson rivers. The Chesapeake and Delaware Canal, still in use today, joins the waters of the Delaware with those of the Chesapeake Bay (www.princeton.edu).

National Wild and Scenic Rivers System

Three sections of the Delaware River are recognized by the National Wild and Scenic Rivers System, which is administered by an interagency US government council. Congress authorized the system in 1968 when it passed the Wild and Scenic Rivers Act. Less than one-quarter of one percent of US rivers are part of this system. Three-quarters of the non-tidal portion of the Delaware River is now included in the national system.

Nearly forty miles of the river between Easton, Pennsylvania (opposite Phillipsburg, New Jersey), and Washington Crossing, Pennsylvania, carries the Wild and Scenic designation, as do tributaries Tinicum Creek, Paunacussing Creek, and a portion of Tohickon Creek.

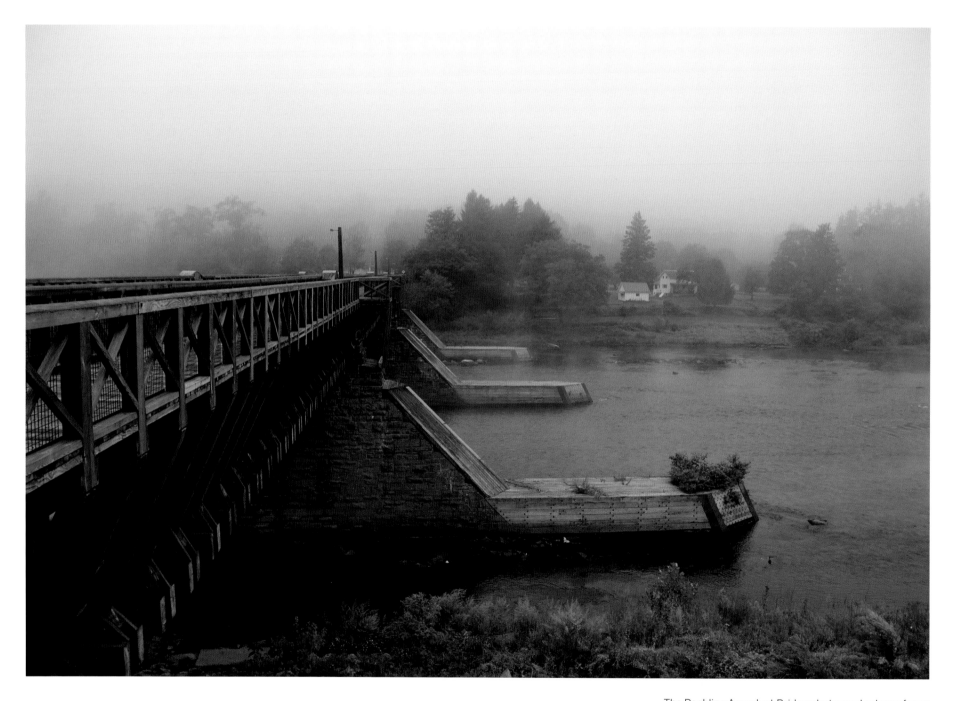

The Roebling Aqueduct Bridge photographed on a foggy
morning on the New York side of the Delaware River.

Delaware River Basin

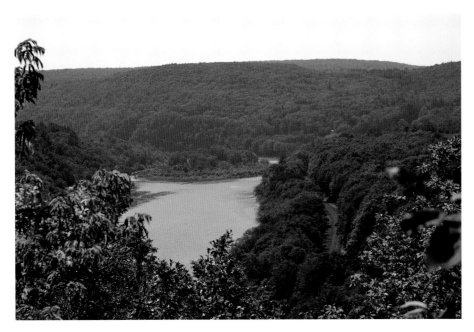

This view of the Delaware River is from a lookout point on New York Route 97, the state's Scenic Byway.

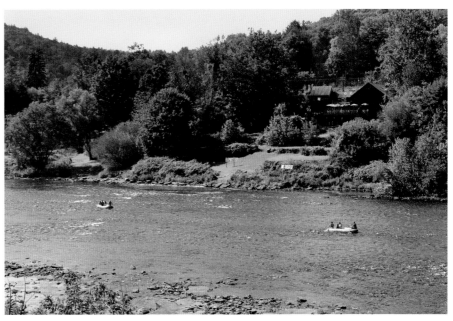

This view of the Delaware River is from the Roebling Aqueduct Bridge on the New York side of the river.

More than seventy miles of the Upper Delaware Scenic and Recreational River and the forty-mile length of the river flowing through the Delaware Water Gap National Recreation Area are also designated.

Designation as a Wild and Scenic River affords the river and some tributaries a somewhat higher level of environmental protection for about a quarter of a mile on both sides of the river. One of the major considerations is prohibiting federal government support for dams that would inhibit the free-flowing condition or water quality of protected rivers. The Delaware is one of those rare rivers that flows free throughout its entire length. Members of the National Wild and Scenic Rivers Coordinating Council include the US Department of the Interior, National Park Service, US Forest Service, Bureau of Land Management, and Department of Agriculture.

Delaware Riverkeeper Network

The Delaware Riverkeeper Network is a non-profit membership organization established in 1988. Its staff and volunteers provide environmental advocacy, volunteer monitoring programs, stream restoration projects, and public education. The organization litigates when necessary to ensure enforcement of environmental laws.

Delaware Riverkeeper Network takes a strong stance on regional and local issues that threaten water quality and the ecosystems of the Delaware River and its watershed. It is the only advocacy organization working throughout the entire Delaware River watershed. According to its website, "Delaware Riverkeeper Network is known for taking positions on controversial issues...backed up with solid information, documentation, and reason, informed by science, law, policy analysis, community need, and genuine passion and commitment to the right outcome" (www.delawareriverkeeper.org).

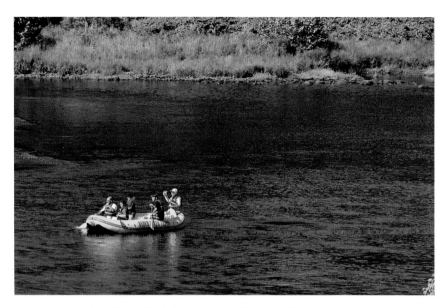

Rafters approach a slight eddy in the Delaware River near the Roebling Aqueduct Bridge on the New York side of the river.

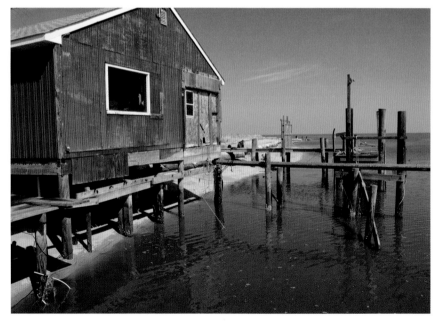

This structure on stilts is part of the DuPont Nature Center on the Delaware Bay at Milford, Delaware.

Delaware Riverkeeper Network officials say the organization's involvement on an issue often translates into a successful result, whether through advocacy, its restoration program, its River Resources Law Clinic, or its water quality monitoring program (www.delawareriverkeeper.org).

Delaware River Basin Commission

The Delaware River Basin Commission, created in 1961, is comprised of the governors of Delaware, Pennsylvania, New Jersey, and New York. The US Army Corps of Engineers is the federal representative on the commission, which uses public funds and has the force of law to oversee management of the river system. According to the commission's website, its programs include water quality protection, water allocation, regulatory review, conservation initiatives, watershed planning, drought management, flood loss reduction, and recreation (www.nj.gov/drbc).

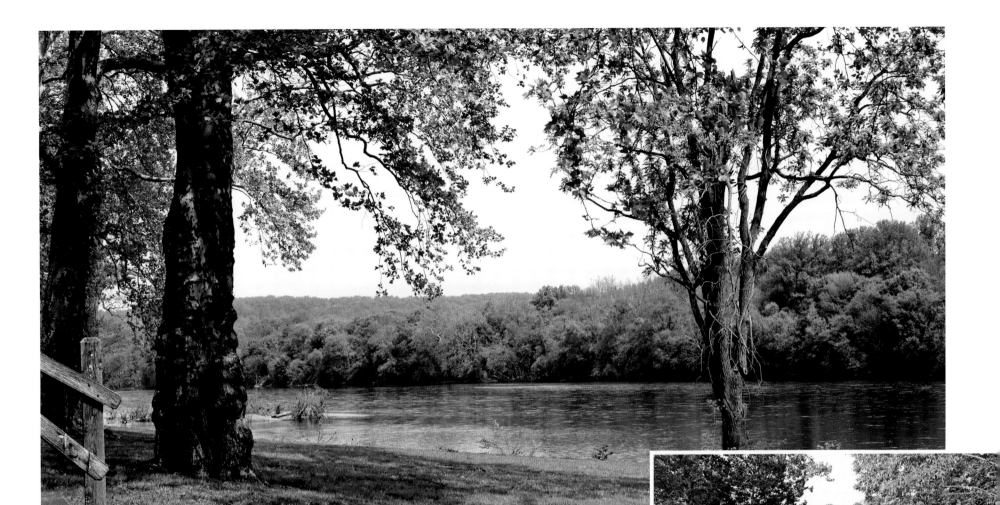

Opposite | Fort Nya Elfsborg historical site on the Delaware River is part of the New Jersey Coastal Heritage Trail Route. Built in 1643 as part of a settlement known as New Sweden, Fort Nya Elfsborg was on the New Jersey side of the Delaware River between Salem and Alloway Creek. The original fort is now under water at Elsinboro Point.

Above | Washington Crossing State Park at Titusville, New Jersey, offers peaceful views of the Delaware on a balmy summer day.

Mill Dam Park in Mount Holly, New Jersey, provides recreation opportunities along the banks of the beautiful Rancocas Creek.

Upper Delaware, Where It Begins—
Hancock, New York, to the Delaware Water Gap

Hancock, New York

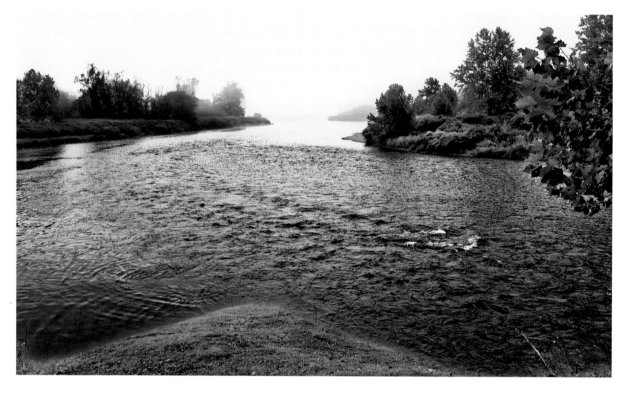

The West Branch Delaware River (right) bubbles as it joins the East Branch (left) to form the headwaters of the Delaware River at Hancock, New York.

This is where it all begins. Hancock is a small town of about 1,500 people at the base of Point Mountain in the picturesque Catskill Mountains of upstate New York. There, the West Branch Delaware River collides with the East Branch Delaware River in a visible display of bubbles and ripples, and the mighty Delaware River flows from that point southward. At Hancock and for the next sixty-five miles, the river provides a convenient dividing line between New York on the east and Pennsylvania on the west.

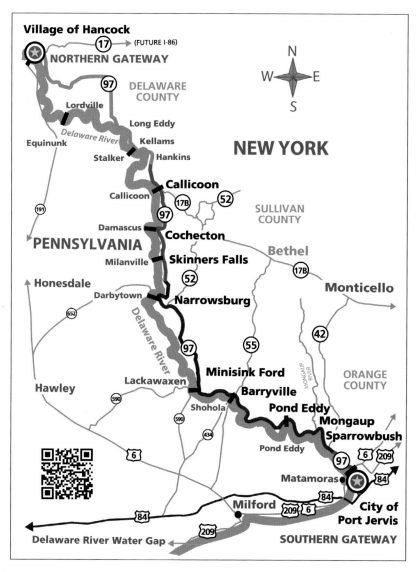

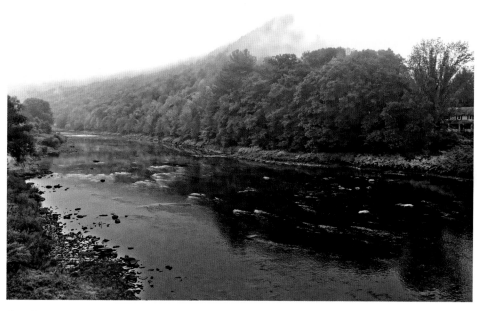

East Branch Delaware River at Hancock, New York, near where it joins the West Branch to form the Delaware.

Hancock, named for Declaration of Independence signer John Hancock, is not only the "Gateway to the Delaware" (the town slogan); it is also the gateway to the Upper Delaware Scenic Byway, New York Route 97. This highway hugs the New York side of the Delaware River from its beginning in Hancock to Port Jervis, New York, sixty-five miles to the south. Built in the early 1930s, the byway has been called the most scenic highway in the East. Based on my experience, this is true. Rising high above the river as a winding two-lane highway of another era, Route 97 features numerous scenic overlooks along its route, and the vistas from most of those points are spectacular. Some points, however, are no longer scenic due to a preponderance of tree growth obstructing the views. This is common along the banks of many rivers where highways were built many years ago with

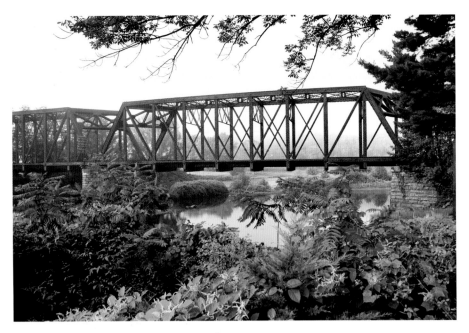

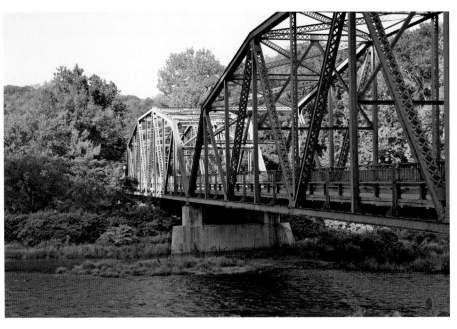

This old bridge crosses the East Branch Delaware River at Hancock, New York, near the confluence with the West Branch.

This bridge over the West Branch Delaware River connects Hancock, New York, with Buckingham Township, Pennsylvania. The photo is from the New York side.

scenic overlooks. Although frustrating for travelers who wish to make beautiful river photos, conservationists agree that the tree growth is actually good for the environment.

In 1983, Austin M. Francis wrote *Catskill Rivers: Birthplace of American Fly Fishing*, a fascinating book about Catskill Mountain rivers that is loaded with interesting historical data about fish populations in the Delaware. We learn that the Erie Railroad was completed in 1851 along the Upper Delaware, offering the earliest known access by rail to fishing in Catskill rivers. In 1870, black bass were stocked in the Upper Delaware, and Atlantic salmon were added in 1871 (Francis 1983, 251).

Kit Clarke, New York jeweler, theatrical agent, and fisherman, fished the Delaware for several decades, Francis wrote. He was also a publicist for the Erie Railroad Company and wrote a series of pamphlets titled *Fishing on the Picturesque Erie*. The Erie line ran from Hoboken, New Jersey, to Port Jervis, New York, where it joined the Delaware and followed its course to Hancock, New York. Completed in 1851, the Erie offered the earliest access by rail to Catskill fishing (Francis 1983, 217).

Considering the Delaware a valuable resource, Erie Railroad management did everything they could to enhance and promote its attractions, Francis added.

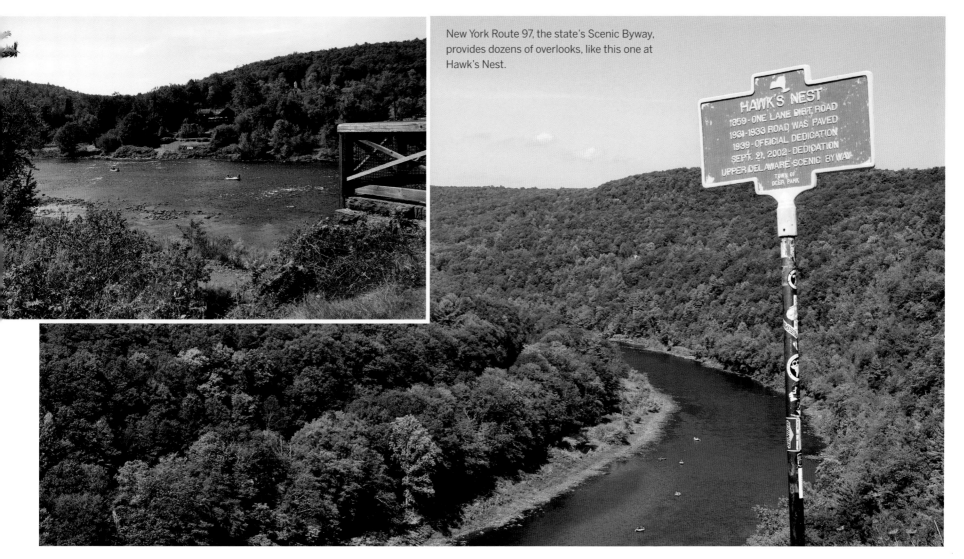

New York Route 97, the state's Scenic Byway, provides dozens of overlooks, like this one at Hawk's Nest.

HAWK'S NEST
1859 - ONE LANE DIRT ROAD
1931-1933 ROAD WAS PAVED
1939 - OFFICIAL DEDICATION
SEPT. 21, 2002 - DEDICATION
UPPER DELAWARE SCENIC BYWAY
TOWN OF
DEER PARK

Near Lackawaxen, Pennsylvania, travelers are treated to scenic views of the Delaware River.

"They regularly stocked the many streams that entered the river along their right of way. In October of 1870, the Erie Railroad transported Ohio River black bass in a perforated basket made to fit the water tank of a locomotive and planted them in the Delaware. The bass took hold and within a few years could be caught throughout the length of the main river and in many of its tributaries as far up as the warmer water prevailed." (Francis 1983, 217–218)

Francis also wrote about an accidental stocking of the Delaware that occurred in the 1880s when an Erie train carrying containers of large rainbow trout was delayed by a wreck. The brakeman on the train was said to have been worried that the trout would die and persuaded his fellow trainsmen to carry the cans a mile or so to Callicoon Creek and dump them in. By 1900 Callicoon creek was famous for its rainbow fishing (Francis 1983, 218–219).

"On the main stem, the Delaware is punctuated by long, deep pools called 'eddies.' Some of them are so big and slow of flow that they appear to be mountain lakes. Looking upstream from an eddy, the river bends and a mountain seems to stand directly across the head of the 'lake.' A view down to the next bend unfolds a like effect; no outlet seems possible."
(Francis 1983, 219)

The author tells us that starting in 1925, the states of New York, Pennsylvania, and New Jersey tried to agree on the uses of the Delaware but failed. The four states failed again in 1927. "By 1931, mounting pressure from New York City for more water forced the issue into the United States Supreme Court, which declared: 'A river is more than an amenity, it is a treasure. It offers a necessity of life that must be rationed among those who have power over it.'" The Supreme Court ruled that the water of the

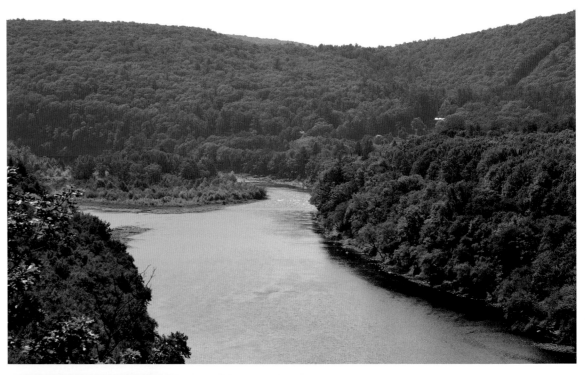

Above | New York Route 97 offers many overlooks of the Delaware River.

The Upper Delaware River is well known for its popularity as a recreational locale. On a warm day, hundreds of boaters can be seen on the water.

Upper Delaware, Where it Begins — Hancock New York, to the Delaware Water Gap

Delaware River must be rationed among the states of Delaware, New York, New Jersey, and Pennsylvania. (Francis 1983, 220).

In 1961, President John F. Kennedy and the governors of Delaware, New Jersey, New York, and Pennsylvania signed the Delaware Basin Compact. It was a sort of "peace treaty" among all the water users, negotiated over the four to five years before it was signed.

"The Delaware is the only major Catskill river not stocked with trout; all its trout are wild. From Hancock to Callicoon, browns and rainbows far outnumber the brook trout. Starting with about an equal number of each, the farther down you go in the twenty-seven-mile trout zone, the more rainbows there are caught for every brown until the ratio gets as high as ten to one. The tributaries moving down toward Callicoon carry progressively higher concentrations of young rainbows. Most of them live in the tributaries for a year or two and then come down to the big river." (Francis 1983, 234)

Lackawaxen, Pennsylvania

This view of the Delaware River at Lackawaxen, Pennsylvania, is looking north from the Zane Grey river access point. The Lackawaxen River joins the Delaware from the left at this point.

Lackawaxen is named for the river that flows through twelve miles of the township. Lackawaxen is the Indian word for "swift waters." Groups of Lenape and Iroquois lived in the township area through the early nineteenth century. The first European settlers came to the area in 1770, and about fifty were killed after engaging with mostly Iroquois and Loyalist fighters in the 1779 Revolutionary War Battle of Minisink.

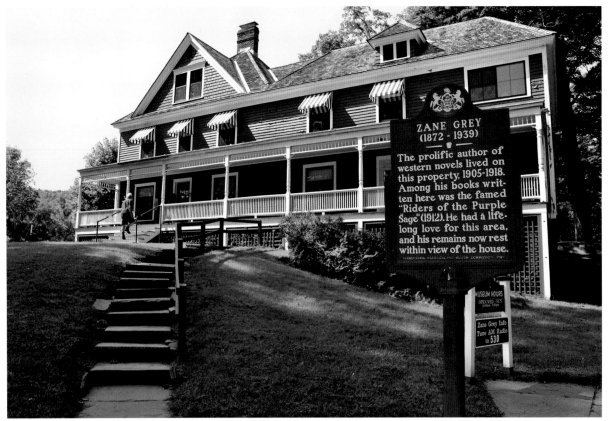

This view shows the confluence of the Delaware River and Lackawaxen River (foreground) at Lackawaxen, Pennsylvania.

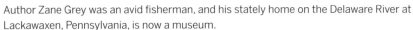

Author Zane Grey was an avid fisherman, and his stately home on the Delaware River at Lackawaxen, Pennsylvania, is now a museum.

Lackawaxen was a major stop along the Delaware and Hudson Canal, which operated from 1829 to 1898. Logging was the main commercial activity of the area, and the canal was essential as a mode of transportation to move the timber downriver to Trenton, Philadelphia, and other markets. The canal company built twenty-eight locks in Lackawaxen Township, raising the elevation of the canal nearly 280 feet. In 1848, the New York and Erie Railroad came through, eventually replacing the canal as the area's chief mode of transportation.

Author Zane Grey, who also wrote about fishing along the Delaware in *Tales of Freshwater Fishing*, lived in Lackawaxen from 1905 to 1918. His stately home at the confluence of the Delaware and Lackawaxen rivers is on the National Register of Historic Places and preserved by the National Park Service as a museum. The site is part of the Upper Delaware Scenic and Recreational River area. Passages in Grey's book show his wit and wisdom, and his propensity for poking fun at himself and other fishermen:

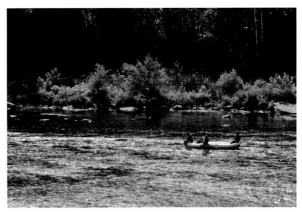

Rafters prepare to enter a mild eddy on the Delaware River along New York Route 97.

Confluence of the Delaware River and Lackawaxen (left) at Lackawaxen, Pennsylvania.

"I see hundreds of canoeists and fishermen come down the Delaware every summer. If they were fly fishermen I would know it. They all stop at the hotel opposite my place. Many of them are kind enough to pay me a little visit. Whatever style of fishermen they were, if they caught a big bass or even made a good catch I would be likely to find out. Most of them, amateurs or otherwise, had good fishing. Some were inclined to ridicule sport on the Delaware. To these I usually told a few bass stories and always had the pleasure of seeing them try politely to hide their conviction of what an awful liar I was. Then I paralyzed them by showing some twenty-six-inch mounted bass, and upon occasions a few live bass of six pounds and over; and upon one remarkable occasion I made several well-meaning but doubtful fishermen speechless and sick... And they delicately implied that they did not believe there were any more bass in the Delaware than were brains in my head." (Grey 1928, 10)

Roebling's Delaware Aqueduct

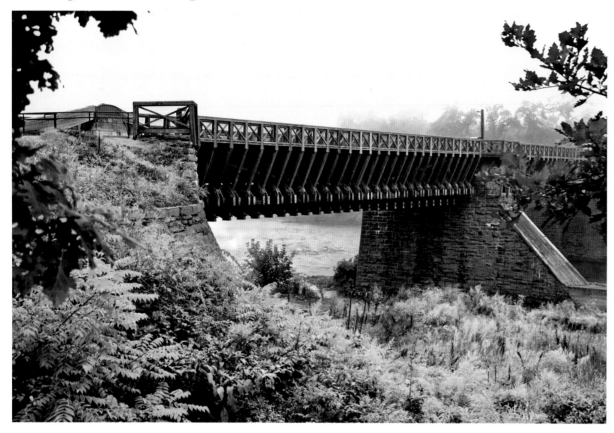

Dating to 1847, the Roebling Aqueduct Bridge is still in use over the Delaware River.

The Roebling Aqueduct Bridge over the Delaware River has been in use since the 1800s.

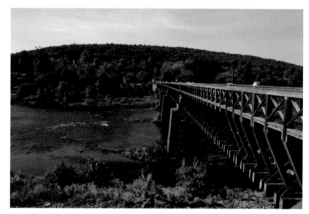

A side view of the truss work on the Roebling Aqueduct Bridge on the New York side of the Delaware River.

When I visited the Delaware Aqueduct in 2015, it was a foggy September morning, and I was concerned about the photos I was making there. So I returned that afternoon for some bright sunlit shots, but I think I like the foggy versions better. Designated a National Historic Landmark, the cable suspension bridge across the Delaware River a quarter-mile south of the Lackawaxen River is also a National Civil Engineering Landmark.

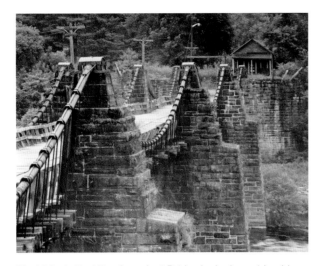

The historic Roebling Aqueduct Bridge looked considerably different in earlier times. *Photographer and date unknown. Courtesy US Library of Congress.*

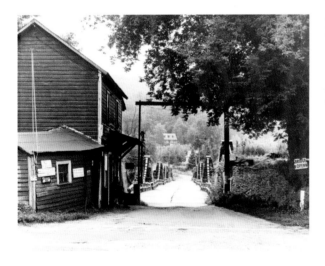

Another historic view of the Roebling Aqueduct Bridge over the Delaware River at Lackawaxen, Pennsylvania. *Photographer and date unknown. Courtesy US Library of Congress.*

The toll house for the Roebling Aqueduct Bridge over the Delaware River has been restored to near original condition.

The Delaware Aqueduct, also known as Roebling Bridge, is the oldest wire suspension bridge in the United States. Just one lane and toll-free, this is where local residents cross the Delaware between Minisink Ford, New York, and Lackawaxen, Pennsylvania. Construction began in 1847 as one of several aqueducts along the Delaware and Hudson Canal. John A. Roebling, the engineer responsible for the famous Brooklyn Bridge in New York City, supervised the construction. The National Park Service purchased the Delaware Aqueduct in 1980 to be part of the Upper Delaware Scenic and Recreational River.

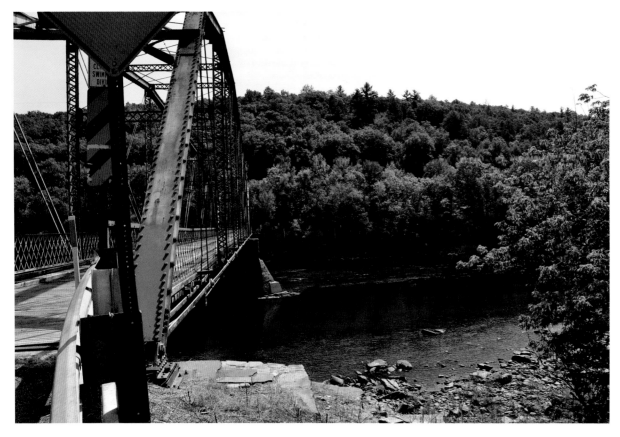

Reduced to just one lane for vehicle traffic, the old Pond Eddy Bridge over the Delaware River at Lumberland, New York, offers wide pedestrian access on both sides—a river photographer's dream.

The one-lane Pond Eddy Bridge over the Delaware River at Lumberland, New York, provides ample pedestrian access. Built in 1903, it was rededicated in 1963 as the All Veterans Memorial Bridge.

Although showing signs of wear, the old Pond Eddy Bridge over the Delaware River at Lumberland, New York, is still in use.

The Pond Eddy Bridge across the river connecting Lumberland, New York, with Shohola Township, Pennsylvania, is on the National Register of Historic Places. Built in 1903, it replaced a bridge that had washed away in a flood. Rusting and badly deteriorated, the All Veterans Memorial Bridge is likely to be replaced. The wooden deck of the one-lane bridge provides sidewalks on both sides where photographers who wish to make beautiful river photos can practice their craft.

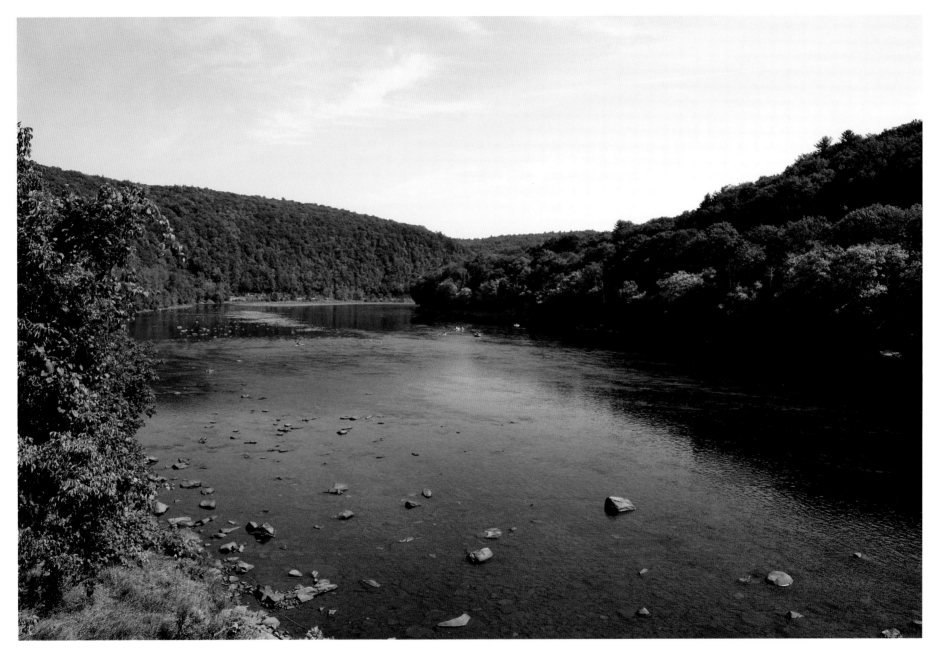

The Delaware River at Lumberland, New York, from the All Veterans
Memorial Bridge, built in 1903.

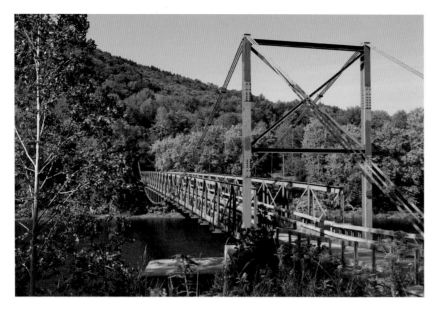

The Kellams-Stalker Bridge, c. 1936, over the Delaware River was photographed at Kellams, New York, with Stalker, Pennsylvania, visible on the other side.

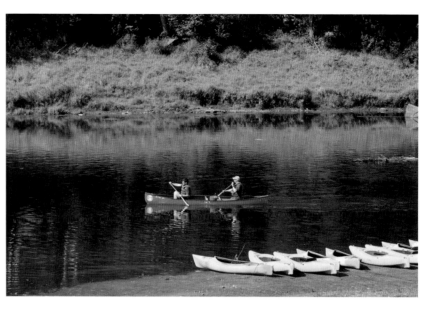

Skinners Falls, New York, is a haven for canoeists. Damascus Township, Pennsylvania, is on the other side of the river.

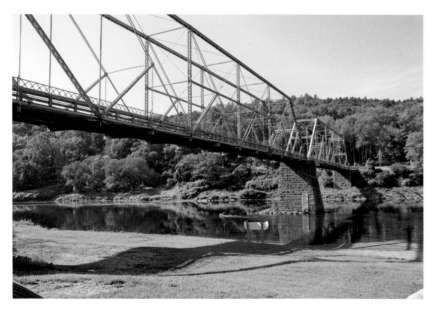

The one-lane bridge over the Delaware River at Skinners Falls, New York, c. 1902, connects with Milanville, Pennsylvania, on the other side of the river.

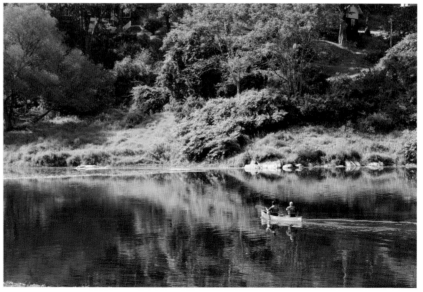

Canoeists enjoy the stillness of the Delaware River near Skinners Falls, New York.

Upper Delaware, Where it Begins — Hancock, New York, to the Delaware Water Gap

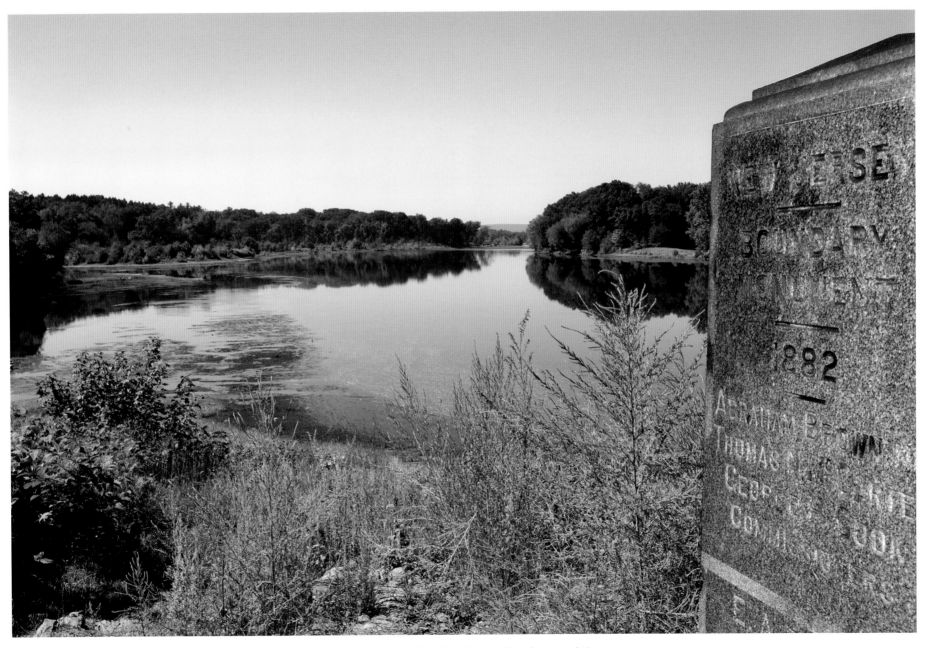

Two rivers and three states can be seen in this one photo. The marker is in Port Jervis, New York. At left is New Jersey and at right is Pennsylvania. Bubbling in from the left is the Neversink River.

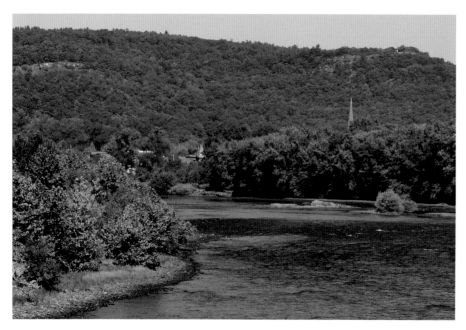

The Delaware River takes a scenic bend at Port Jervis, New York. Pennsylvania is on the left side in this photo.

West End Park is a peaceful setting on the Delaware River in Port Jervis, New York.

Port Jervis is an interesting place to take photographs. At the southeastern tip of Laurel Grove Cemetery under Interstate 84, one can see three states and two rivers. Facing south, the Delaware becomes the boundary between New Jersey and Pennsylvania, after having been the boundary between New York and Pennsylvania for the sixty-five miles from Hancock to the north. Standing at the tip of Port Jervis, one can photograph all three states and the confluence of the Delaware and the Neversink River, which joins it from the northeast. An 1882 surveyor's granite block marks the boundary with New Jersey.

A lone duck takes a sunbath at West End Park on the Delaware River in Port Jervis, New York.

The city of nearly 9,000 residents across the river from Matamoras, Pennsylvania, was created in 1798 and became a city in 1907.

Situated between the Appalachian and Shawangunk Mountains near state parks, forests, and game lands, city leaders call it the Scenic Queen of the Shawangunk Range. It was once a boat basin and repair center along the Delaware and Hudson Canal. The New York and Erie Railroad reached Port Jervis in 1847 and eventually replaced the canal as the major form of transportation through the area (www.portjervisny.org).

From West End Park on the Delaware River in Port Jervis, New York, a slight eddy is visible. Pennsylvania is on the other side of the river.

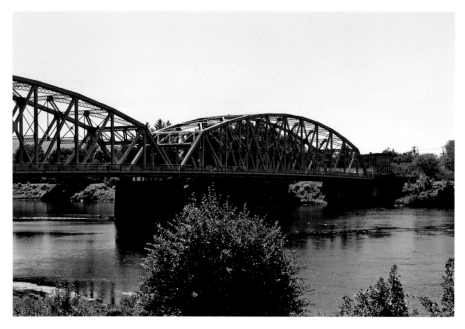

The Mid-Delaware Bridge connects Port Jervis, New York, with Matamoras, Pennsylvania, on the opposite side.

Matamoras, Pennsylvania, on the Delaware River sits opposite Port Jervis, New York.

The Upper Delaware Scenic and Recreational River is a National Park and part of the National Wild and Scenic Rivers System. National Park Service officials say this stretch of the river between Hancock and Port Jervis, New York, has some of the "highest ecological integrity" and excellent water quality of any large river in the Atlantic Coast region. It is the least developed section of the river (www.nps.gov).

The Upper Delaware teems with wildlife, including white-tailed deer, muskrat, raccoon, beaver, mink, foxes, bats, coyotes, bobcats, and snapping turtles. More than 200 species of birds call this area home, including the majestic bald eagle.

Friends of the Upper Delaware River

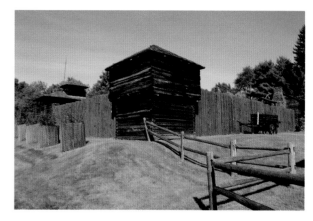

Fort Delaware, New York, sits on a bluff high above a bend in the Delaware River at Narrowsburg, New York. The fort and museum are accurate depictions of life on the Delaware in the 1750s.

Pedestrians on the Pond Eddy Bridge over the Delaware River at Lumberland, New York, enjoy remarkable views of the Delaware River.

Friends of the Upper Delaware River, based in Hancock, New York, has formed coalitions with river advocacy groups based at various locations along the route of the river. The group champions the causes of water-release issues, restoration projects, and protection of fisheries and ecosystems associated with the Delaware River. Its stated mission is "to protect, preserve, and enhance the ecosystem and cold-water fishery of the Upper Delaware River System and to address any environmental threats to our area for the benefit of local communities, residents, and visitors to the region" (www.fudr.org).

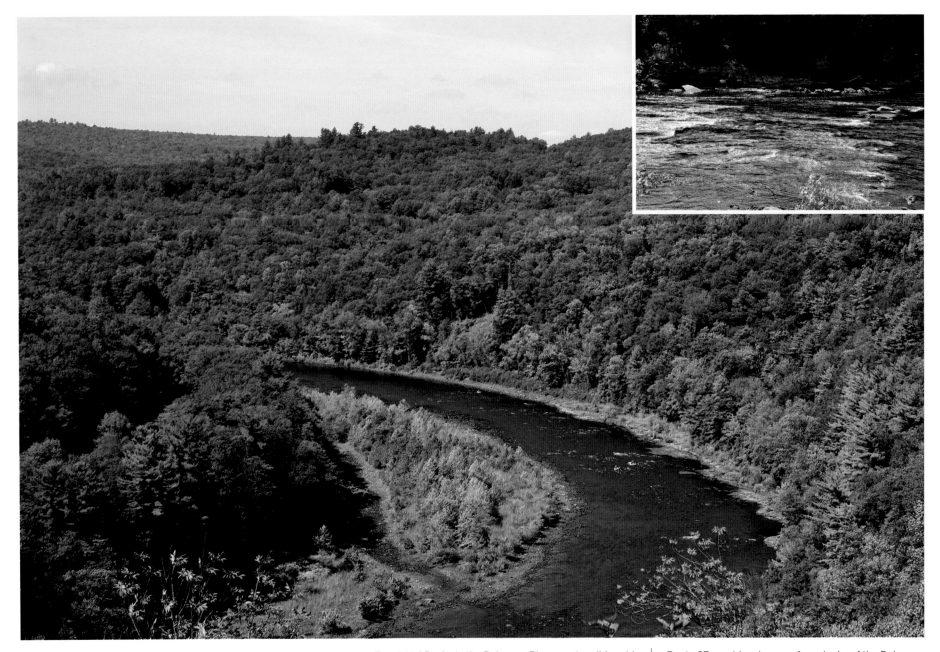

Top right | Rocks in the Delaware River create mild rapids along New York Route 97, the state's Scenic Byway.

Route 97 provides dozens of overlooks of the Delaware River like this one.

Upper Delaware, Where it Begins — Hancock, New York, to the Delaware Water Gap

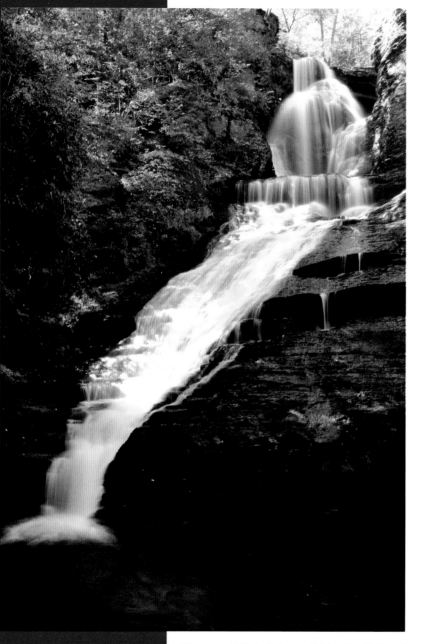

Dingmans Falls in Delaware Water Gap National Recreation Area is one of the most visited attractions in the park.

Delaware Water Gap National Recreation Area

There aren't enough pages in this book, or any other, for that matter, to fully document the extreme natural beauty of every aspect of the Delaware Water Gap National Recreation Area. It doesn't matter, however, because my words alone wouldn't even begin to adequately describe how it feels to experience the oneness with nature that comes from just being there. It is, after all, forty miles long and 70,00 acres, encompassing both the Pennsylvania and New Jersey sides of the river.

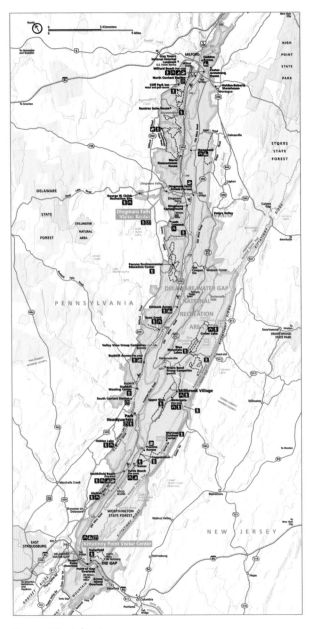

National Park Service map.

This national recreation area has more than 100 miles of hiking trails, including twenty-seven miles of the Appalachian Trail. Located just ninety minutes from New York City, the Delaware Water Gap's recreational opportunities attract millions of visitors every year. The park is home to wildlife habitats, historic villages and structures, and ancient agricultural fields. The section of river that flows through this national resource is designated a wild and scenic river by the National Wild and Scenic Rivers System.

If not for a handy global positioning system in my car one September morning, I might still be lost in the park. I was trying to follow the ancient Old Mine Road, built in the 1700s, from the New Jersey side of Dingmans Ferry Bridge in the north to the Kittatinny Point Visitor Center near the end of the park in the south. I somehow ended up on the seemingly seldom-traveled Sandyston-Flatbrookville Road, which runs parallel to Old Mine Road for many miles. The position of the bright sun that day didn't help me navigate because much of the road was shaded by trees. Travelers who wish to take that route be warned: some of it is one lane only due to road and hillside erosion, and some stretches have potholes big enough to lose your car in. Still, none of that takes away from the natural wonders one experiences along the way.

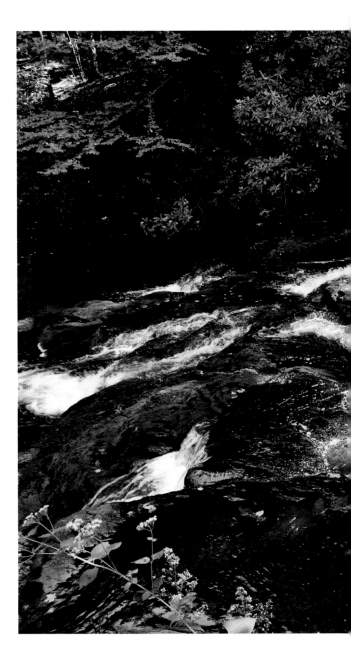

Dingmans Creek is a wild tributary of the Delaware River in Delaware Water Gap National Recreation Area.

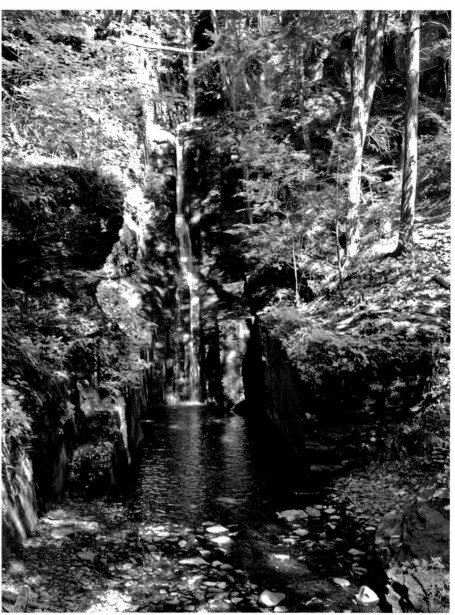

Though not as stunning as Dingmans Falls, nearby Silverthread Falls provides yet another natural wonder in the Delaware Water Gap National Recreation Area.

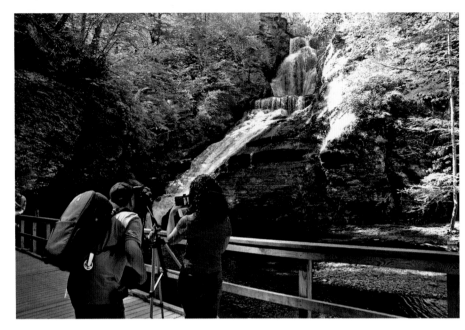

Tourists from all over the world visit Dingmans Falls in Delaware Water Gap National Recreation Area.

Dingmans Ferry, Pennsylvania, in the Delaware Water Gap National Recreation Area, provides boat access.

Because I got lost while trying to travel along Old Mine Road, I found myself in Walpack Township, New Jersey (known as Wallpack in earlier times), and a fascinating historical place called Walpack Center, which dates to about 1731. I had to stop and photograph the beautiful Sandyston Creek from a one-lane bridge built in 1889. I didn't mind standing on the old bridge for a long time. The only sounds to be heard that sunny morning were trickling water and chirping birds, which didn't seem to mind me being there.

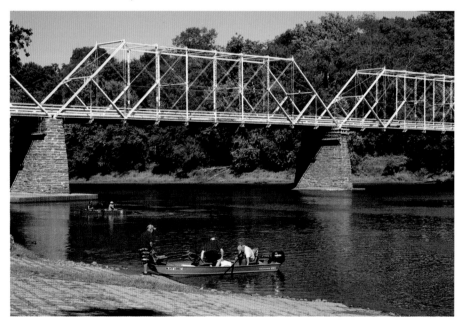

The Dingmans Ferry Bridge, built in 1900, crosses the Delaware River in the Delaware Water Gap National Recreation Area, and provides a convenient boat launch at its base.

Delaware Water Gap National Recreation Area

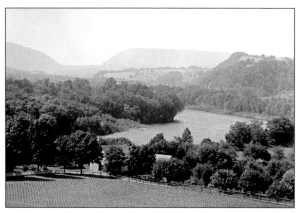

Delaware Water Gap c. 1890.
Courtesy US Library of Congress.

The Dunnfield Trail at Delaware Water Gap National Recreation Area requires several crossings of Dunnfield Creek, seen here in this 1972 photo

This 2015 visit was my first time back since 1972, when we called it simply Delaware Water Gap, even though it had received the National Recreation Area part of its name in 1965. In 1971, my photographer pal, the late Tom Beitz, introduced me to the rough and rocky Dunnfield Trail, which provides many opportunities for scenic camping along the way to Sunfish Pond high above the river. The trail to Sunfish Pond is a grueling seven and a half miles to the 1,000-foot summit and follows the tranquil and picturesque Dunnfield Creek, which is designated a wild trout stream. Following the trail requires numerous creek crossings and sturdy hiking boots; don't try this in sneakers. In 1972, my beautiful wife, Sharon, proved to be a rugged free spirit by hiking the trail and camping with me among the hemlocks. We still talk of the experience, which neither of us will ever forget.

This one-lane steel deck bridge over Sandyston Creek in Wallpack Township, New Jersey, was built in 1889 and is still in use. The creek feeds into the Delaware River. With little vehicle traffic in a wilderness area, photographers can get marvelous creek images from the bridge.

Dingmans Ferry provides almost unlimited recreational opportunities for river enthusiasts.

Visitor Centers

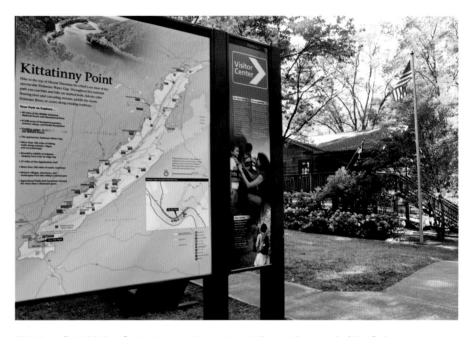

Kittatinny Point Visitor Center is a must-see stop at the southern end of the Delaware Water Gap National Recreation Area in Pahaquarry Township, New Jersey. From the canoe launch behind the center, visitors can view the magnificent Delaware Water Gap.

No matter which direction you approach the park from, Kittatinny Point Visitor Center near the southern end of the park on the New Jersey side of the river is a must see. This center provides park information, exhibits, rest rooms, drinking water, and an astounding view of the Delaware Water Gap. Walk or drive to the canoe launch behind the center and be treated to the spectacular view of the actual Delaware Water Gap to the east just before the river takes a turn to the south. It's the view that millions have seen and has made the park famous. At this visitor center hikers can access the Appalachian National Scenic Trail, and other park trails.

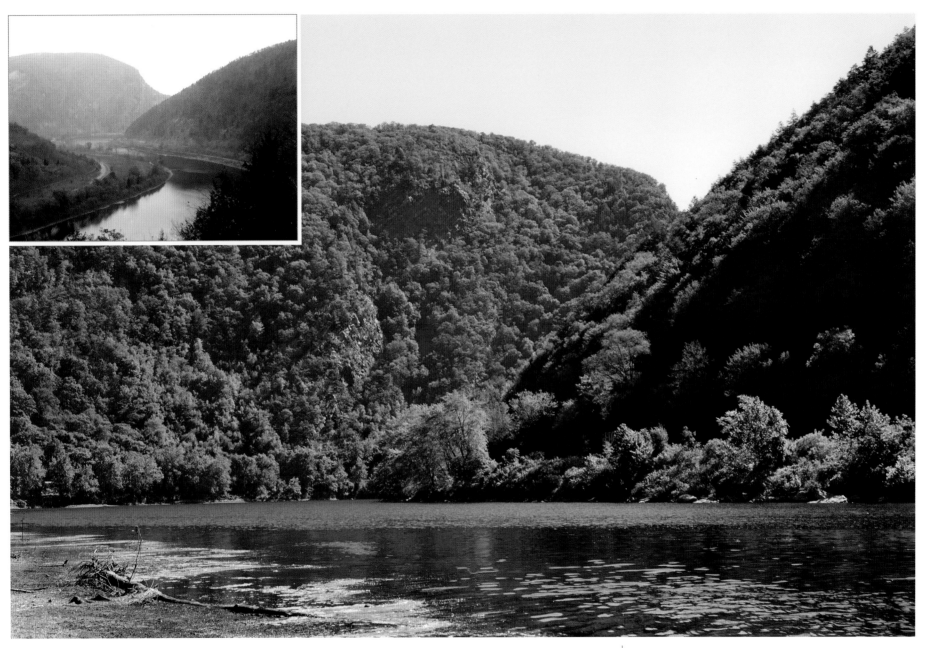

The Delaware Water Gap is seen here in all its glory on a September day. Photographed from behind the Kittatinny Point Visitor Center at the southern end of the Delaware Water Gap National Recreation Area, various versions of this image have been advertised in travel brochures for more than a century.

Delaware Water Gap, looking east from Winona Cliff, Pennsylvania c. 1900. *Courtesy US Library of Congress.*

The steel deck of this Sandyston Creek bridge has served it well for over 100 years.

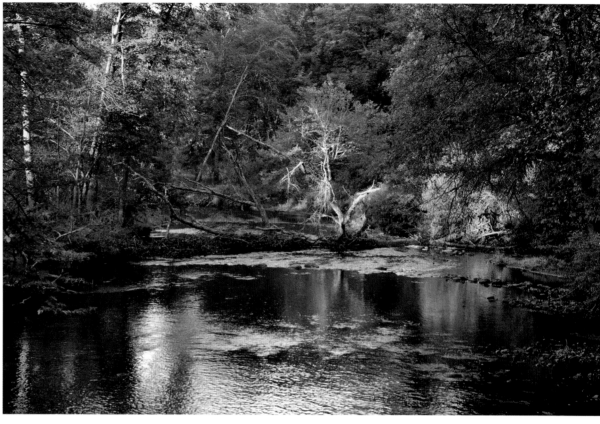

The one-lane bridge is the perfect place to photograph views of the creek, which feeds into the Delaware River.

Near the northern end of the park on the Pennsylvania side of the river is the Dingmans Falls Visitor Center. This is a typical park visitor center and so much more. Here, you can follow a boardwalk along Dingmans Creek to perhaps the most scenic views to be found in the park—Dingmans and Silverthread waterfalls. At the end of the trail, one can simply stand and marvel at the natural wonder that is Dingmans Falls, or if you're in good shape, climb the steep steps 130 feet to the top of the falls. Along the boardwalk, visitors are treated to the eighty-foot Silverthread Falls. Not as massive or perhaps as picturesque as Dingmans Falls, it is nonetheless a wonder. The boardwalk is on a slight incline that might be difficult for some older or disabled visitors, but park officials have thoughtfully placed rest benches along the way.

Other visitor centers are Park Headquarters on the Pennsylvania side and Millbrook Village on the New Jersey side. More information about the visitor centers, including phone numbers, highlights, and operating schedules, is on the National Park Service website at www.nps.gov.

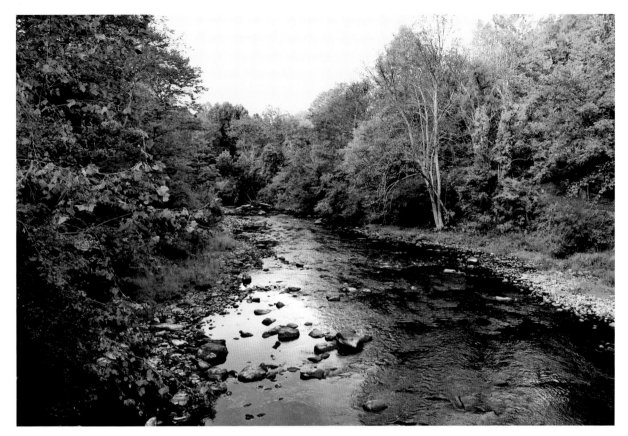

The steel deck of this Sandyston Creek bridge has served it well for over 100 years.

Flat Brook is a strikingly beautiful creek in the Delaware Water Gap National Recreation Area near Flatbrookville, Sussex County, New Jersey. This view is about a half mile from where the brook flows into the Delaware River.

Old barns, ancient agricultural fields, and historic buildings dot the Delaware Water Gap National Recreation Area.

People have been hiking the trails in Delaware Water Gap for more than 100 years. This dapper hiker is on the trail to Winona Cliff, Pennsylvania, c. 1890. *Courtesy US Library of Congress.*

Delaware Water Gap to Easton and Phillipsburg

Pennsylvania's Scenic Byway Route 611

A small brook flows into Delaware Canal at Easton, Pennsylvania.

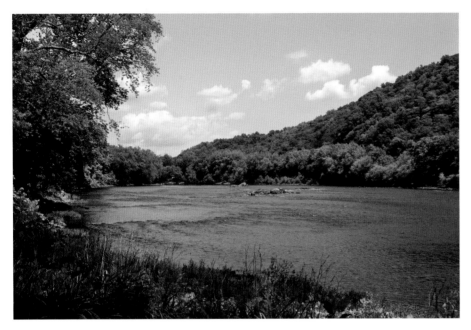

Rocks in the Delaware River near a scenic overlook on Route 611 north of Easton, create mild ripples and white water.

The Delaware River at Lower Mt. Bethel Township, Pennsylvania, paints a shimmering reflection of the sky on this sunny day. Harmony Township, New Jersey, is on the other side.

This two-lane highway hugs the Pennsylvania side of the Delaware from about six miles north of Easton to about ten miles south, and rivals New York's Route 97 in scenic beauty. Travelers can find several overlooks along the route, but an overgrowth of trees obstructs the views in several places. It's obvious that the twentieth-century engineers who built the overlooks did not anticipate the tree growth all these years later. However, enough places exist along the route for gorgeous views of the river.

The Pennsylvania Byways Program qualifies designated routes for federal funds for improvements, such as paved shoulders, interpretative signs, and scenic overlooks. The Pennsylvania Department of Transportation manages the state's Scenic Byways.

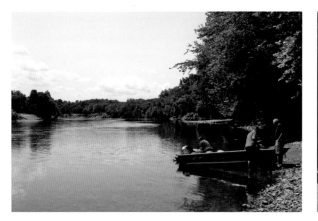

Fishermen launch their boat at Sandts Eddy boat ramp on Route 611 north of Easton.

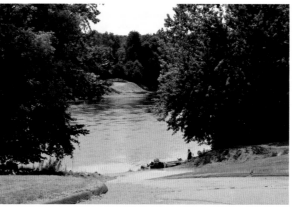

Sandts Eddy boat ramp on the Delaware River, off Route 611 north of Easton, is popular among local fishermen and canoeists.

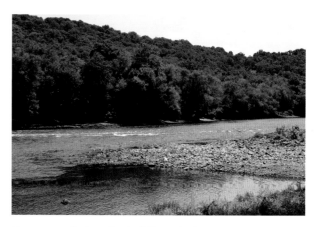

Near an overlook on Route 611 north of Easton, one of the many eddies is visible on the river. This one doesn't create a hazard for most boaters.

The Pennsylvania Fish and Boat Commission established the Sandts Eddy boat access point on scenic Route 611 in Lower Mount Bethel Township, five miles north of Easton. It sits on a straight, mile-and-a-quarter-long stretch of the river between two picturesque bends opposite Harmony Township, New Jersey. The eddy at this stretch of the river produces a slight white-water effect, though it doesn't appear to be treacherous for boaters. A short distance from the river, a large quarry belonging to the Lehigh Portland Cement Company exploded in March 1942, killing thirty-one people. The plant closed in the early 1960s.

This access point is a favorite for anglers with small boats. "From this Pennsylvania ramp down to Easton, the river is punctuated by huge emerged boulders, fast powerful runs, and deep churning channels. It is a great place to fish for shad" (www.gameandfishing.com).

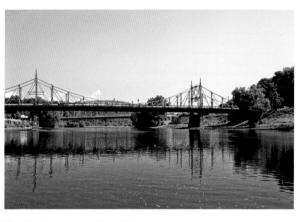

The Northampton Street Bridge, also known as the Free Bridge over the Delaware River at Easton, has had traffic flowing across it since 1896. The Route 22 toll bridge is in the background.

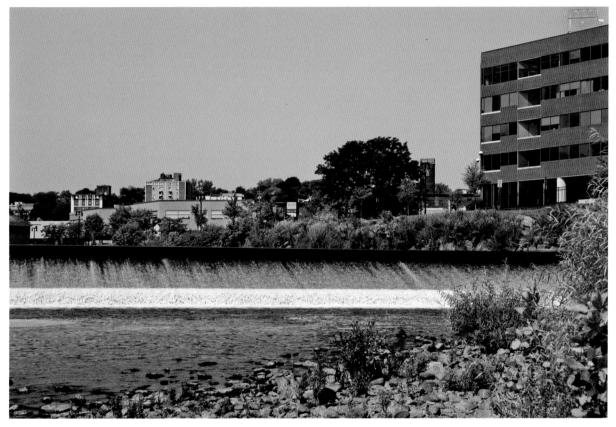

The Easton Dam marks the confluence of the Lehigh and Delaware Rivers at Easton.

The Northampton Street Bridge, also known as the Free Bridge, connects Easton with Phillipsburg, New Jersey. Downtown Easton is in the background.

Easton has an active arts community with galleries and events throughout the year. When I visited on a warm September day, I stumbled upon the Riverside Festival of the Arts, which featured juried fine art, craft exhibits, poetry readings, lots of eclectic food, and live music. This is an annual event of the Arts Community of Easton. It was a beautiful day on the riverbank for a festival, the art was world-class, and the mellow crowd was into the music (www.eastonart.org).

Arts Community of Easton treasurer Howard McGinn said the 2015 festival was its nineteenth annual event. "We hope to continue if for a long time," McGinn said. "ACE, with approximately 160 members, also conducts an annual studio tour in late April, and spring and fall members' shows."

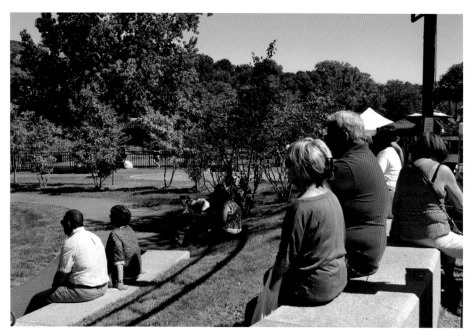

Thousands of residents and visitors flood Easton's Karl Stirner Arts Trail for the annual Riverside Festival of the Arts, which features juried art, live musical performances, and abundant food of all ethnic origins.

McGinn said the Delaware and Lehigh rivers play an important role in the Easton area, and were the subject of many entries in a painting contest at the festival.

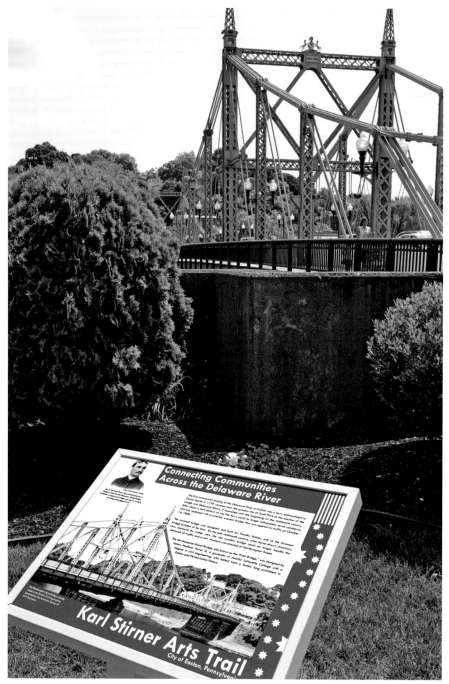

Northampton Street Bridge, also known as the Free Bridge, over the Delaware River at Easton. Phillipsburg, New Jersey, is on the other side.

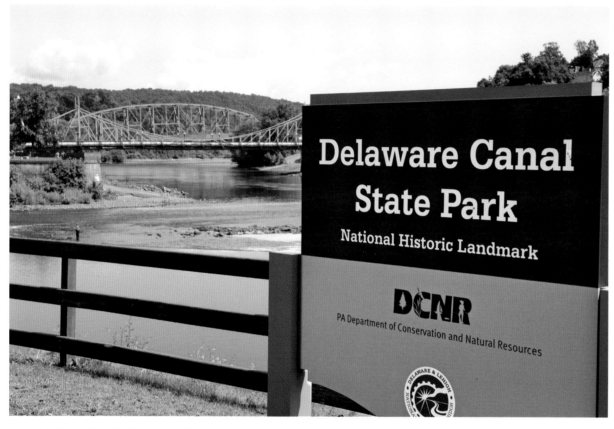

Delaware Canal State Park beckons office workers in downtown Easton during lunch hour.

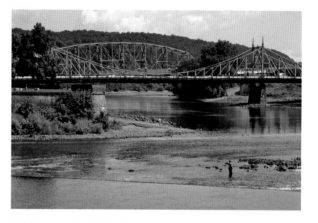

A fisherman tries his luck near the bottom of the Easton Dam at the confluence of the Lehigh and Delaware Rivers.

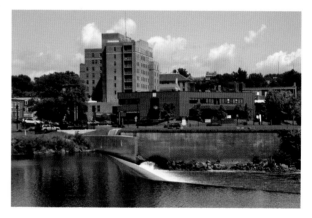

Downtown Easton, viewed across the Easton Dam on the Lehigh River.

I couldn't believe my luck on that same day as I stumbled upon yet another picturesque scene, this one in Easton's Hugh Moore Park. I only went there because small roadside signs advertised a canal boat ride, and I decided to check it out. When I arrived, I saw two women in nineteenth-century dress guiding mules on a towpath with an authentic-looking canal passenger boat at the end of a long rope. This is the site of the National Canal Museum between the Lehigh Canal and Lehigh River. The sight set my photo instincts in motion, and I went right to work. Also at the park, I met an artist who was painting a tranquil scene of the Lehigh River. Information about the National Canal Museum is online at www.canals.org.

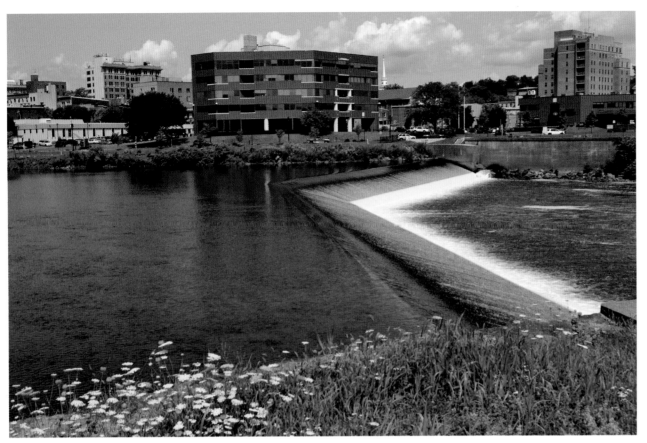

The Lehigh River (left) flows over the Easton Dam into the Delaware River.

The Delaware Canal State Park includes many historic artifacts, including this lock near the confluence of the Lehigh and Delaware rivers, Easton, Pennsylvania.

Mayor Sal Panto describes his city as a river community with three of the downtown boundaries formed by the Delaware and Lehigh Rivers and Bushkill Creek. "These waterways contribute significantly to the economy in boating, fishing, swimming, and recreational activities along the shores, including special events," Panto said. "The natural trout-producing Bushkill and the Delaware River shad attract fishermen from all over the region. The Delaware offers opportunities for boating, fishing, tubing, and hiking along its shores."

Panto said the Delaware has naturally cleansed itself in the Easton-Phillipsburg area over the last five decades, and increased regulatory and inspection activities have assured fewer pollutants are going into the river. "As a child I fished in the Delaware and tubed and boated many times," Panto said. "Today, the river is a place to relax and just enjoy the serenity and sounds of the water."

The Northampton Street Bridge across the Delaware connects Easton with Phillipsburg, New Jersey. The bridge, called the "free bridge"

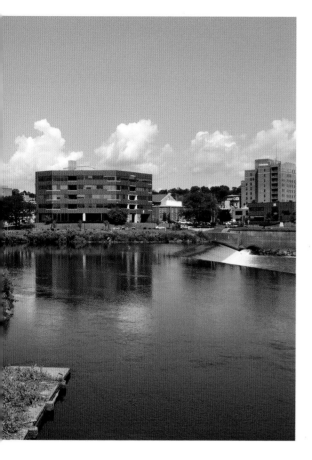

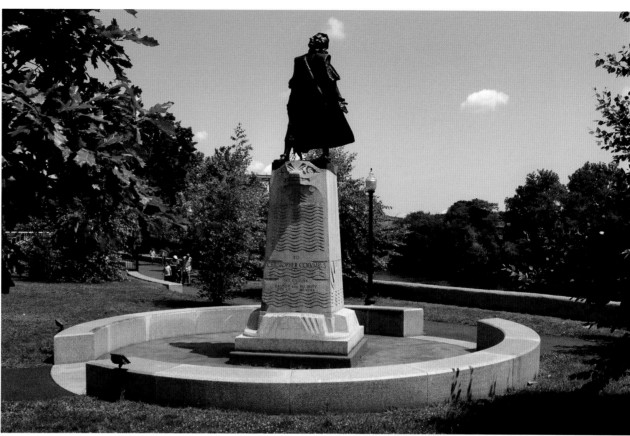

A statue of Christopher Columbus at the Karl Stirner Arts Trail on the Delaware River demonstrates Easton's support for the arts.

by locals because there is no toll, celebrated its 100th anniversary in 1996. It is the last bridge with Gothic detail in the United States, and is a National Civil Engineering landmark.

Easton has long been home to a company whose products every kid in America knows about, as do millions of kids in other countries. Crayola was formed as Binney & Smith Company, which launched its iconic brand of wax crayons in 1903. Crayola, still headquartered in Easton, operates an attraction for kids called The Crayola Experience. I dropped my grandkids off there one day in 2014 to scream and play with the other kids while I chose the peace and quiet of Easton's riverbank for picture taking. I was moved when one of my grandchildren made a crayon with my name on it. They bought T-shirts and still talk about it. More information is available at www.crayola.com.

Thomas Penn, son of William Penn, and Benjamin Eastburn surveyed a tract of land now known as Easton in Northampton County at the confluence of the Delaware and Lehigh Rivers.

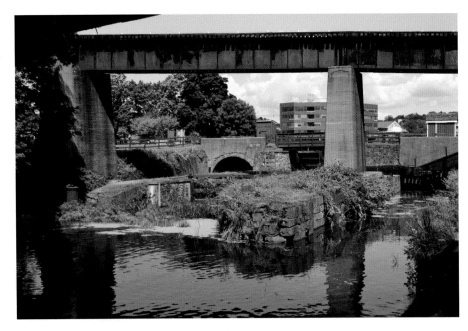

A lock on the Delaware Canal at Easton sits idle in silent testament to the heyday of canal transportation systems that were replaced by railroads in the late nineteenth century.

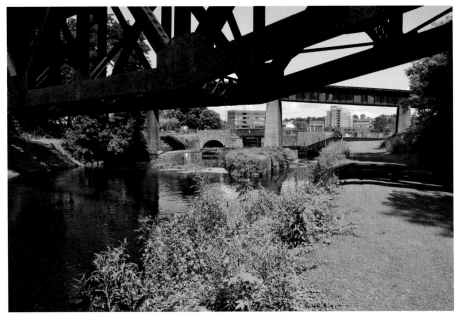

Visitors to the Delaware Canal State Park in Easton have miles of hiking trails to explore.

Penn named the town after his mother-in-law's estate, Easton-Neston, in Northamptonshire, England. On July 8, 1776, one of only three public readings of the Declaration of Independence occurred in Easton's Great Square, now called Centre Square. Once a year, Easton residents take part in Heritage Day, which features a reenactment of the reading.

The history of Easton, and information about these attractions and more, is on the city's website at www. easton-pa.gov.

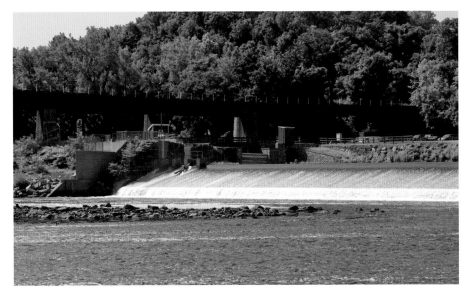

A railroad bridge crosses both the Lehigh and Delaware Rivers near the Easton Dam at the confluence of the two rivers.

Phillipsburg, New Jersey

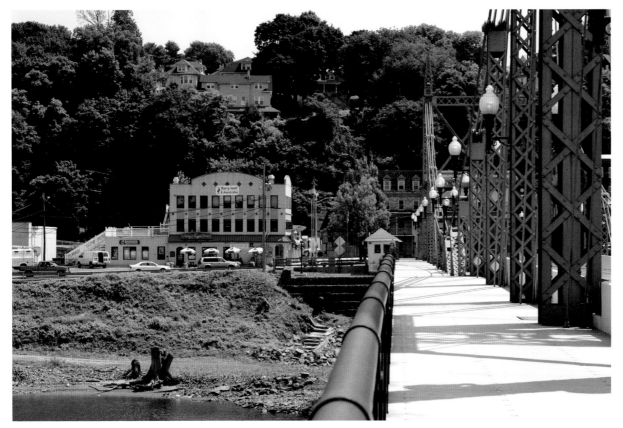

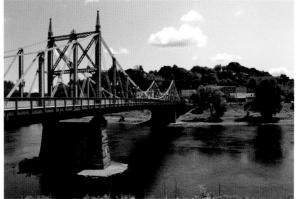

The Northampton Street Bridge over the Delaware River has seen vehicular and pedestrian traffic between Phillipsburg and Easton since 1896.

The legendary Jimmy's Doggie Stand at the foot of the Northampton Street Bridge on the river bank in Phillipsburg has been serving hot dogs to Phillipsburg and Easton residents since 1908.

Phillipsburg is a city of 15,000 people opposite Easton at the confluence of the Delaware and Lehigh Rivers. Because of this location, Phillipsburg was a major transportation hub for 100 years during the era of canals, and even later into the railroad era. Between the 1820s and 1920s, Phillipsburg was the end of the Morris Canal, which provided transport between the Delaware River and New York City. Five major railways served the area, some of which are long bankrupt.

Because Phillipsburg is rich in railroad history with five rail lines having served the area, it is home to the Phillipsburg Railroad Historians, which operates a museum in town. The museum includes several cabooses and boxcars, and two locomotives. Two other organizations in Phillipsburg also celebrate the history of railroading. New Jersey Transportation Heritage Center operates out of Phillipsburg's Union Train Station, which the organization is restoring to its 1914 architecture. The mission of this organization is to restore railroad, bus, truck, canal, trolley, and ferry

artifacts and history. The Susquehanna & Western Technical & Historical Society operates Delaware River Railroad Excursions out of Phillipsburg. Information about the Delaware River Excursions is on the website at www.877trainride.com/trips.

The city shows PG-rated movies in Shappell Park during the summer months at dusk. On Thursdays from June through early September, residents can attend music concerts in the park. For three days in July each year, the city features Ole Towne Festival, which includes concerts in the park, benefit softball games, car shows, a soccer tournament, miniature train rides, pony rides, festival games, tethered balloon rides, and more. Information on Ole Town Festival can be found at www.oletownefestival.org.

For more information about Phillipsburg, visit the city's official website at www.phillipsburgnj.org.

Morris Canal

What's left of the Morris Canal in Lopatcong Township flows under a highway bridge. It is one of the few places where canal water still flows.

The Morris Canal was considered an engineering marvel of its time in 1825 because it overcame gravity to propel canal boat traffic up more than seven hundred feet from the Delaware River at Phillipsburg, New Jersey. From Phillipsburg, it headed eastward through the Musconetcong River valley to Lake Hopatcong before beginning its descent of nine hundred feet to the Hudson River a hundred miles away. Canal boats made the climb by a series of twenty-three locks and a like number of inclined planes, which used railway equipment to move the boats up the inclines. The boats were floated onto cable cars, which were hoisted by chain up the incline and then re-floated on the other side.

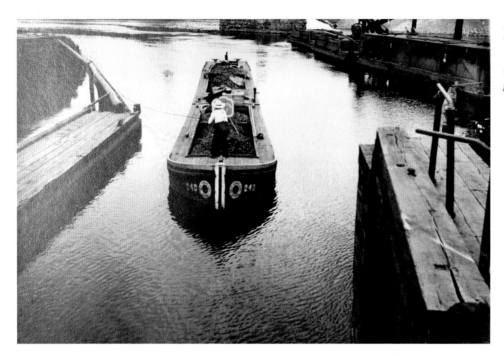

A canal boat enters the Delaware Canal at Phillipsburg from the Lehigh River. Boats were ferried across the Delaware River to the Morris Canal by a cable-supported trolley. Date and photographer unknown. *US government photo, US Library of Congress.*

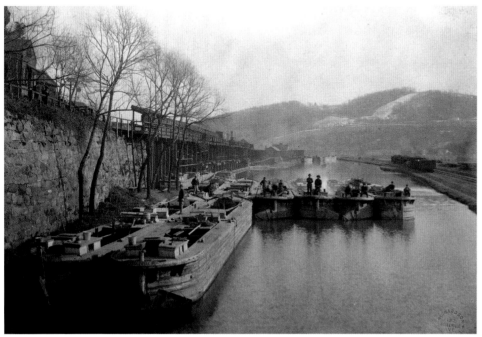

Empty canal boats float high in the water at Port Delaware on the Morris Canal, Phillipsburg. Date and photographer unknown. *US government photo, US Library of Congress.*

These inclined planes were expensive to build and maintain, but the demand for transportation of coal across New Jersey to the New York City area was large.

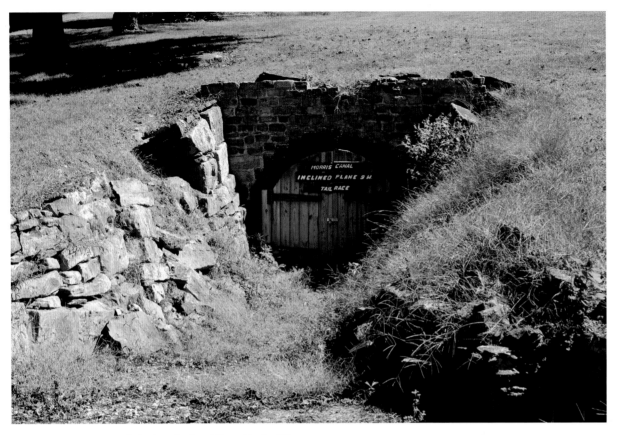

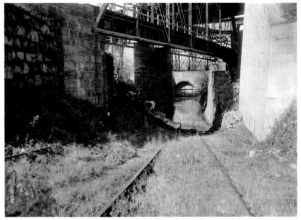

This 1970 photo of the entrance to the Morris Canal from the Delaware River Portal at Phillipsburg, New Jersey, shows the remains of rails that were used to propel canal boats up inclines along the canal. *US government photo by Jack E. Boucher.*

This is all that remains of a lock on Inclined Plane No. 9 of the Morris Canal, Lopatcong Township, New Jersey.

The Morris Canal and the Lehigh Canal, linked by the Delaware River, connected the coalfields of the Pocono Mountains with the New York-New Jersey markets. It also transported farm products, iron ore, raw materials, and construction materials. Having been overcome by railroads in the 1850s, the canal was leased to the Lehigh Valley Railroad in 1871, and taken over by the State of New Jersey in 1922. It was formally abandoned in 1924.

Phillipsburg to Trenton

New Hope, Pennsylvania

Historic New Hope, Pennsylvania, is directly across the river from Lambertville, New Jersey.

The famous Bucks County (Pennsylvania) Playhouse on the Delaware River, as seen from Bulls Island State Park in New Jersey.

New Hope, Pennsylvania, is one of the most visited places along the Delaware River, due in large part to its reputation as a community with roots in the arts, antiques, and theater. People come from hundreds of miles away to experience the avant-garde in the arts, plus music, fine dining, and the scenic beauty of the river. Historians say New Hope was once an industrial town that used the power of the river to drive its many mills. Artists began to move into the area 100 years ago, attracted by the beauty of the river valley, old stone structures, barns, and mills. Industry left town many years ago, and its gristmills are in ruins or registered as historic landmarks, but the arts community has remained and flourished.

With a population of less than 3,000, New Hope sits at the confluence of the Delaware

River and Aquetong Creek, across the river from Lambertville, New Jersey. Perhaps the biggest attraction has been the Bucks County Playhouse. Housed in the former Parry gristmill on the riverbank, the playhouse has hosted prominent actors and performances since 1939. Other attractions include the Buckingham Valley Vineyards and Winery, the Bucks County Children's Museum, Ghost Tours of New Hope, New Hope and Ivyland Railroad, and New Hope Film Festival. Information about these attractions can be found at www.visitnewhope.com.

Dr. Claire E. Shaw, president of the New Hope Borough Council, said New Hope embraces the river's beauty, even though there is no public access. "We critically scrutinize structural improvements and new building projects to be certain what limited view of the river we have is not obscured from the roadway," Shaw said.

"Environmentally, the river has greatly improved over the past twenty years, with cleaner water and a documented increase in the number of different species of birds and wildlife," Shaw said. "Our sightings of the American bald eagle, mergansers, and red bellied woodpeckers, to name a few, have led me to believe the river is in good shape."

Shaw said choosing to live in New Hope along the banks of the Delaware has been one of the highlights of her life. "Every day is a vacation here," she said. "For me, the water element is a source of peace, offering an escape from the hectic pace of life. It's a wonderful backdrop for that morning cup of coffee, moments of solitude, or one of our famous parties. Life is good and the Delaware River really is a part of that."

Lambertville, New Jersey

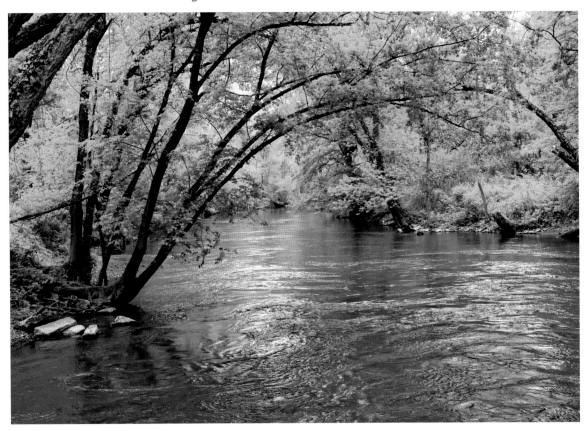

The Delaware and Raritan Canal.

Lambertville is one of the oldest towns in Hunterdon County, settled in 1705. The village of nearly 4,000 residents across the river from New Hope grew into an industrial center with the construction of the Delaware and Raritan Canal, remnants of which still flow through the town. This beautiful little community of artists, shops, and restaurants would be a welcome stop on anyone's tour of the Delaware River. Take in one of the many galleries in the downtown area and then dine overlooking the tranquil canal before strolling along the canal's banks in the Delaware and Raritan Canal State Park.

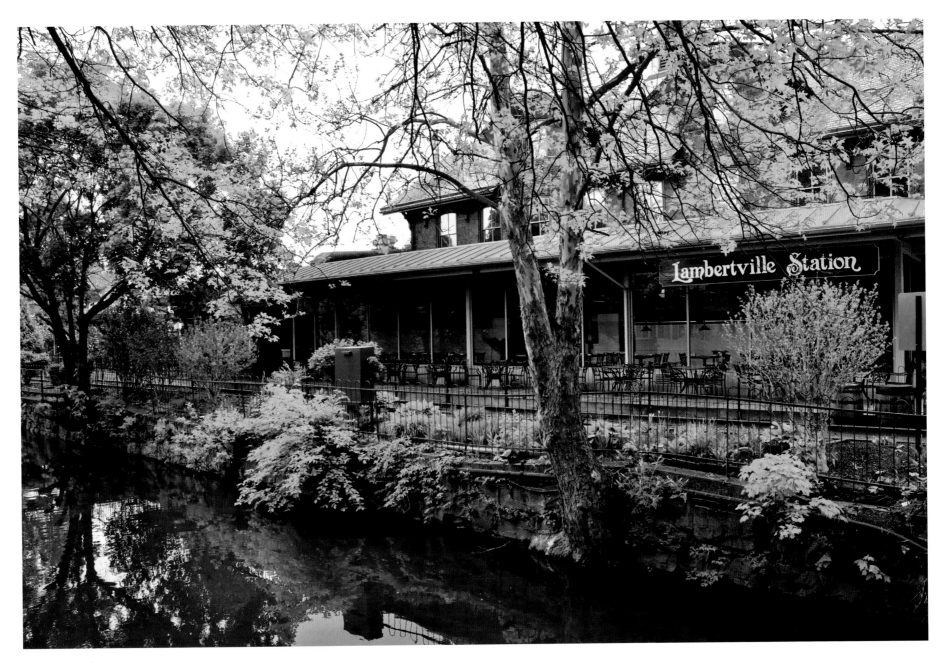

Lambertville Station is a popular tourist stop at Lambertville, New Jersey, on the Delaware and Raritan Canal.

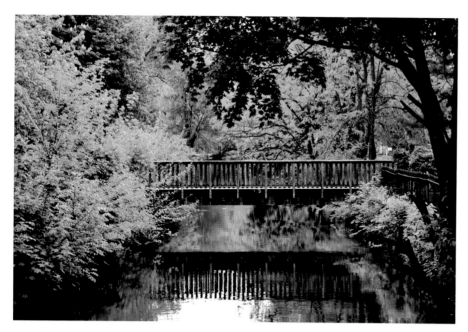

Footbridges abound on the Delaware and Raritan Canal.

The Delaware and Raritan Canal provides a scenic backdrop for this business in Lambertville, New Jersey.

This small city displays typical early American architecture, featuring Victorian-style homes and federal townhouses. Restaurants and antique shops attract visitors from a wide area. The city was named for John Lambert, a resident who had been a US senator and acting governor of New Jersey.

The Delaware and Raritan Canal extended from Bordentown, just below Trenton on the Delaware River, to New Brunswick on the Raritan River. It was forty-four miles long and drew its water from the Delaware at Raven Rock. A variety of boats passed through the canal, including mule-towed canal boats, sailboats, steam tugboats towing barges, freight boats, yachts, and naval vessels. The canal opened for business in 1834 and closed in 1932.

Prallsville Mills, Stockton, New Jersey

Centre Bridge Inn at Solebury Township, Pennsylvania, across the Delaware River from Stockton, New Jersey.

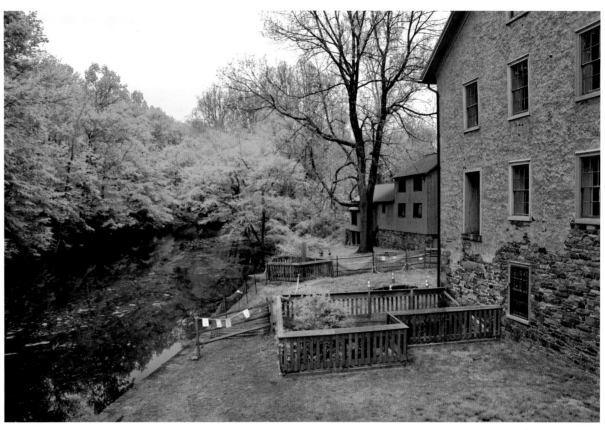

Prallsville Mills is a popular tourist attraction on the Delaware and Raritan Canal, Stockton, New Jersey.

Prallsville Mills is a historic site on the Delaware and Raritan Canal in Stockton, New Jersey. The remains of an early industrial center is still intact and is a cultural and historical tourist attraction. The ten-building site that dates to 1720 includes a gristmill, linseed oil mill, sawmill, and grain storage facility. It is on the National Register of Historic Places and is part of the Delaware and Raritan Canal State Park. The mills ceased operations in the 1950s. Today the site houses an art gallery and hosts private parties, weddings, and concerts (www. prallsvillemills.org).

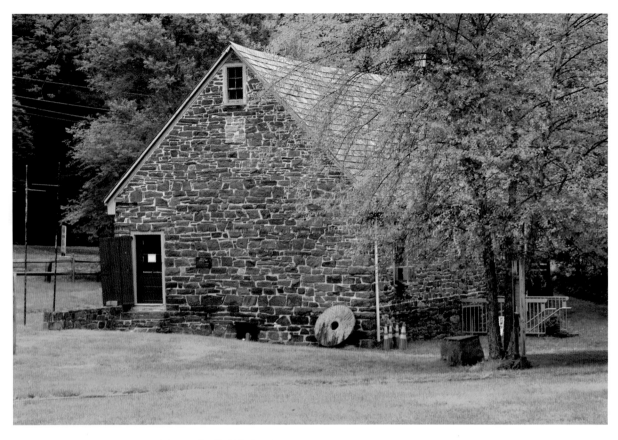

This colonial structure is part of the Prallsville Mills tourist area on the Delaware and Raritan Canal, Stockton.

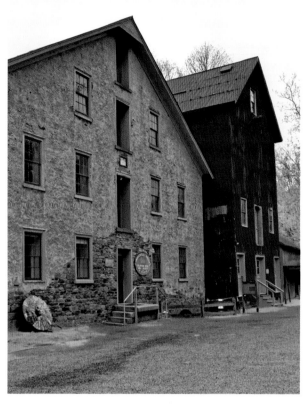

A popular tourist attraction, Prallsville Mills is a historic ten-building complex on the Delaware and Raritan Canal, Stockton.

Bulls Island State Park, Stockton, New Jersey

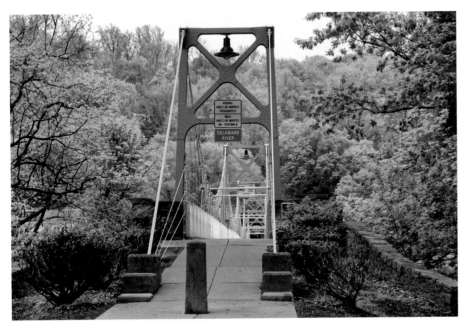

The Lumberville-Raven Rock footbridge crosses the Delaware River into Pennsylvania at Bulls Island State Park, Raven Rock, New Jersey.

View of Lumberville, Pennsylvania, from the footbridge.

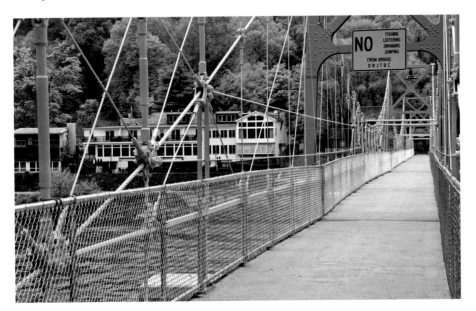

The Lumberville-Raven Rock footbridge.

Bull's Island Recreation Area is a seventy-nine-acre state park on a small forested island with the Delaware River on one side and the Delaware and Raritan Canal on the other. The Lumberville-Raven Rock suspension footbridge across the Delaware River connects the recreation area with Lumberville, Pennsylvania. A stroll across the bridge reveals a photographer's paradise of scenic river vistas both north and south.

The Delaware and Raritan Canal flows alongside Bulls Island State Park. The Delaware River is on the other side of the island.

Bulls Island State Park offers boat ramps like this one.

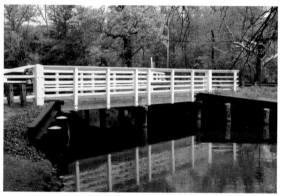

Several bridges across Delaware and Raritan Canal, like this one at Titusville, New Jersey, allow vehicle crossings.

The park no longer permits camping due to the danger of trees falling because of root decay caused by flooding. A camper died there in 2011 as a result of a falling tree. However, in 2015, the Department of Environmental Protection was working on a plan to assess the tree hazard with a goal of eventually reopening the site to camping.

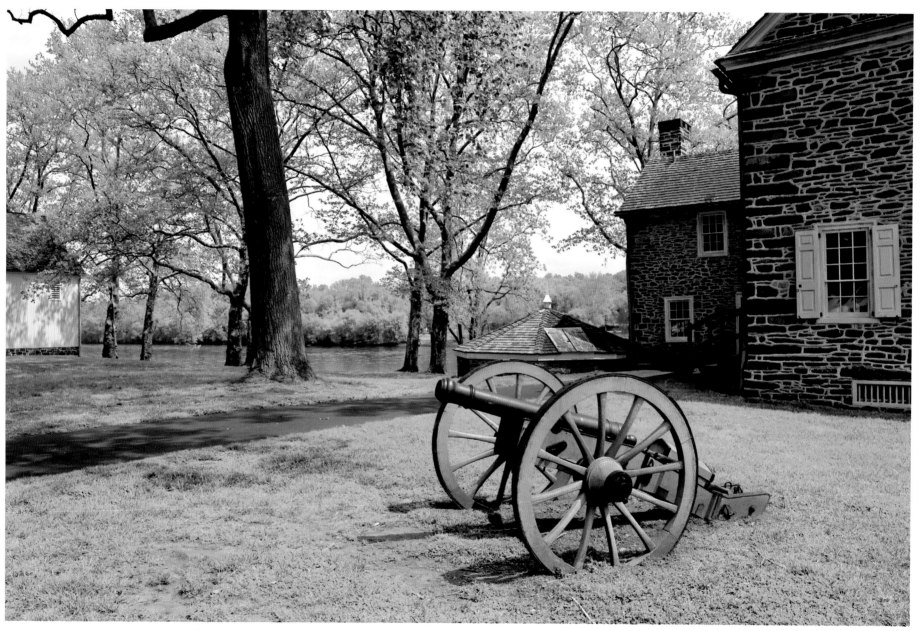

A cannon stands ready to defend the buildings at Washington Crossing Historic Park,
Washington Crossing, Pennsylvania.

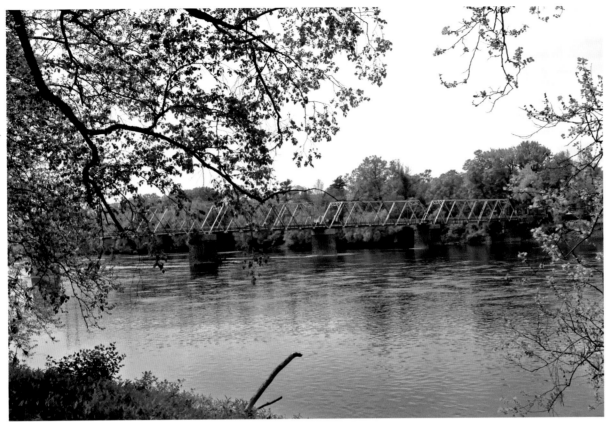

A bridge across the Delaware River connects Washington Crossing State Park, New Jersey, with Washington Crossing, Pennsylvania.

This path leads to the Delaware River at Washington Crossing Historic Park, Washington Crossing, Pennsylvania.

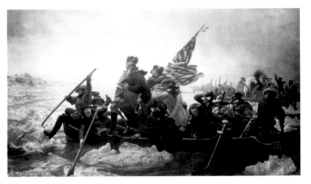

Watercolor painting *Washington Crossing the Delaware* (1846) by Emanuel Leutze. *Courtesy US Library of Congress.*

George Washington made history on Christmas Day 1776 when he began crossing the Delaware and led his army into Trenton, New Jersey, the next day during the Revolutionary War. After fighting blinding snow and sleet as they crossed the river, Washington's troops marched into Trenton on December 26, 1776, and attacked Hessian outposts in a stunning victory that was a turning point in the war. Parks on both sides of the river at this point commemorate the crossing.

Washington Crossing might be confusing because it is the name of a town in Pennsylvania, as well as the 500-acre Washington Crossing Historic Park in Pennsylvania, and Washington Crossing State Park across the river in Titusville, New Jersey. One can drive between the two parks by crossing the Washington Crossing Bridge. Every year on Christmas Day, the Pennsylvania town of Washington Crossing, formerly known as Taylorsville, conducts a re-enactment

Washington Crossing Historic Park at Washington Crossing, Pennsylvania, features authentic colonial buildings.

of Washington crossing the river. The town is a National Historic Landmark. For more information about the Pennsylvania sites, call (215) 493–4076 or visit www.washingtoncrossingpark.org.

George Washington crossed the Delaware River at this point in Washington Crossing, Pennsylvania, on his way to defeat the Hessians at Trenton during the Revolutionary War.

Stone was the most prevalent building material in the colonies during the Revolutionary War. This building on the Delaware River at Washington Crossing Historic Park has endured many harsh winters.

The New Jersey site features fifteen miles of trails, wildlife habitat, a museum, and a visitor center. Wildlife in the park includes deer, fox, migrating birds, raccoons, owls, hawks, and bluebirds. In winter, visitors may cross-country ski on the many trails in the park. The park offers outdoor nature programs for visitors including schools, groups, and community organizations. An observatory is operated by the Amateur Astronomers Assoc-iation of Princeton on Friday nights during April through October. For more information, call (609) 737-0623 or visit www.state.nj.us.

The Mahlon K. Taylor House is a short walk from the Delaware River at Washington Crossing Historic Park.

A quaint gazebo offers a peaceful place for tourists to rest at Washington Crossing Historic Park.

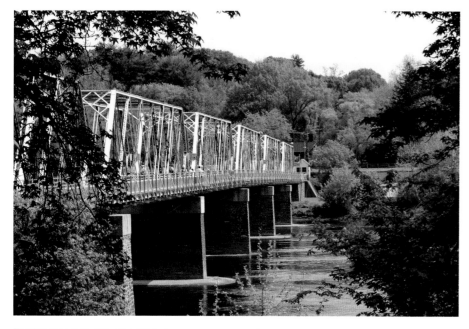

The Washington Crossing Bridge.

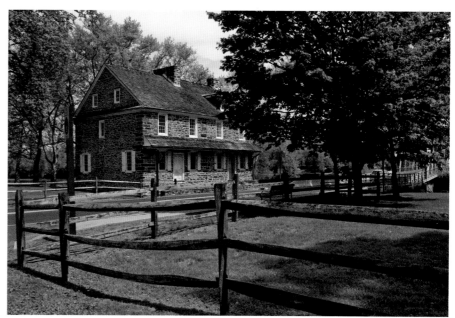

The McConkey Ferry Inn at Washington Crossing, Pennsylvania, is one of the original 1776 buildings featured in the park.

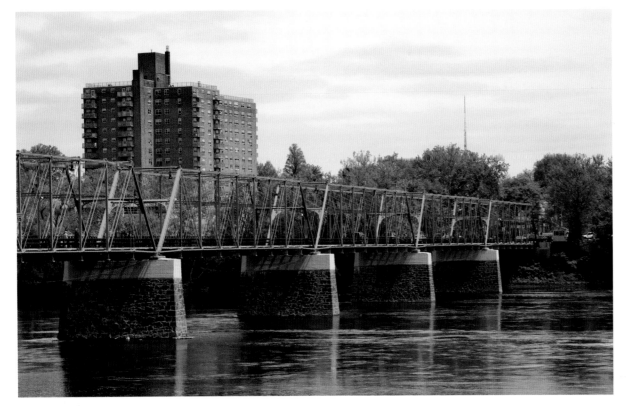

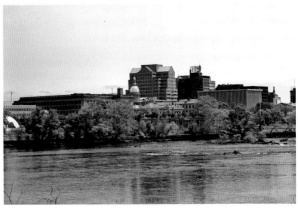

Trenton, New Jersey's capital, was the national capital for a short time after the Revolutionary War. This view is from across the Delaware River in Morrisville, Pennsylvania.

Trenton, New Jersey, photographed from a flood wall across the Delaware River at Morrisville, Pennsylvania.

Trenton, population almost 85,000, is well known as the capital of New Jersey, and it was the capital of the United States for a brief time after the Revolutionary War in November and December 1784. The US Census Bureau groups Trenton with New York City's metropolitan area, but it is actually much closer to Philadelphia. The city's records date back to 1719, when it was called "Trent-towne," for William Trent, a leading landholder. It became New Jersey's capital in 1790.

Quakers established the first settlement at Trenton in 1679 in the area that was called "The Falls of the Delaware." During the Revolutionary War, the Battle of Trenton was George Washington's first recorded military victory.

Trenton is home to many arts and culture sites: New Jersey State Museum, State Library, Trenton City Museum, Trenton War Memorial, William Trent House, Trenton Battle Monument, and the Old Barracks Museum, to name just a few. The city is also home to Trenton Thunder, a class AA minor-league baseball affiliate of the New York Yankees. The team plays in the beautiful, 6,000-seat Arm & Hammer Park stadium on the bank of the Delaware River.

Scudders Falls creates a slight white water on the
Delaware River near Trenton, New Jersey.

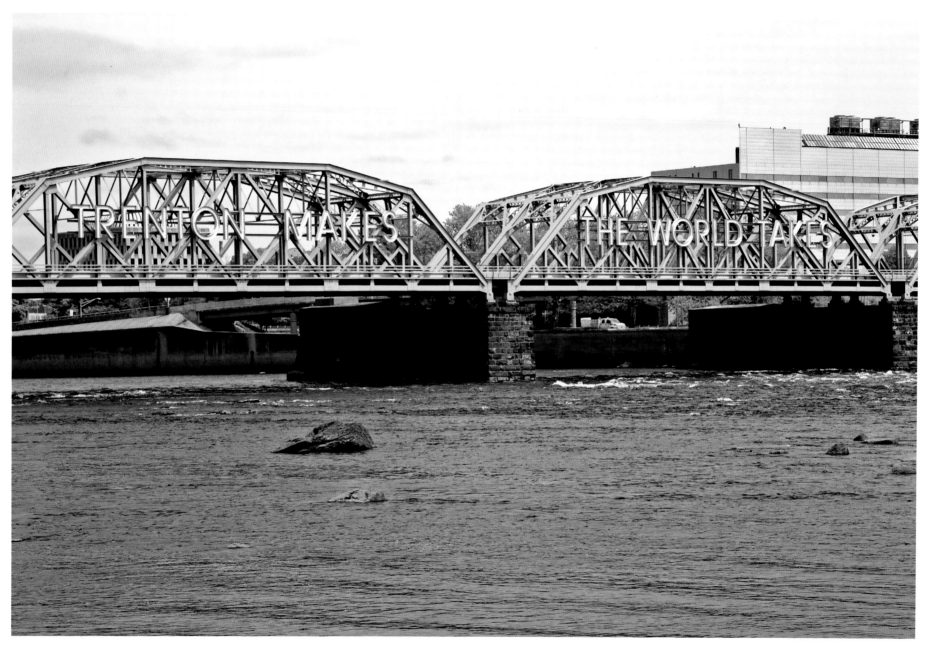

The world-famous "Trenton Makes" bridge across the Delaware River connects Trenton, New Jersey, with Morrisville, Pennsylvania.

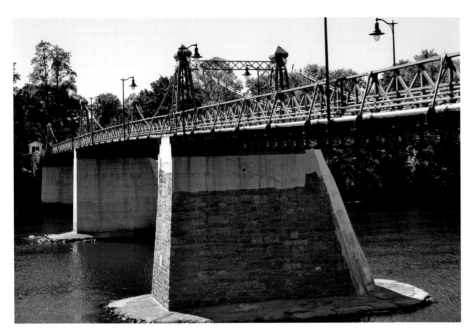

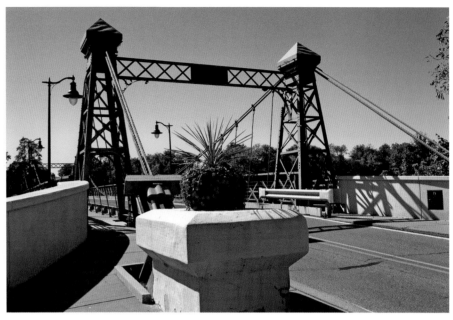

John A. Roebling, the engineer responsible for the famous Brooklyn Bridge in New York, erected this bridge over the Delaware River at Riegelsville, Pennsylvania, in 1904. The bridge connects Riegelsville with Pohatcong Township, New Jersey

The entrance to the bridge over the Delaware River at Riegelsville, Pennsylvania, erected by John A. Roebling in 1904, is well maintained and adorned with flowers.

This famous slogan, emblazoned on the Delaware River bridge connecting Trenton with Morrisville, Pennsylvania, dates to 1911. Trenton industrialists made steel rope for suspension bridges, anvils, pottery, wall plaster, cars, farm tools, mattresses, watches, bricks, and linoleum, and these products and more were indeed shipped around the world.

The slogan, which appears on a neon sign more than 300 feet long, came from a 1910 Chamber of Commerce contest aimed at promoting the city's manufacturing ability. Businessman S. Roy Heath is credited with coming up with the slogan. Although the city's manufacturing era is long gone, city leaders are still proud of their sign.

This c. 1970 view of the bridge over the Delaware River at Riegelsville, Pennsylvania, shows it had wooden planks for its road surface instead of the paved surface used today. *US government photo, US Library of Congress.*

Bucks County, Pennsylvania, and Burlington County, New Jersey

Burlington, New Jersey

A sculpture of an American bald eagle stands in a riverside park on the Delaware River at Burlington, New Jersey.

John Alexander, director of public affairs for Burlington, has much to say about the Delaware River and what it means to his city. "We call ourselves the historical Port City of Burlington, founded by William Penn's Quakers who landed here in 1677 on Green Bank, anchoring their ship, *Shield* (which is on the city's seal), in the river and walking over

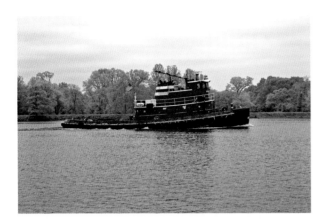

A tugboat heads up the Delaware River near the Burlington-Bristol Bridge at Burlington.

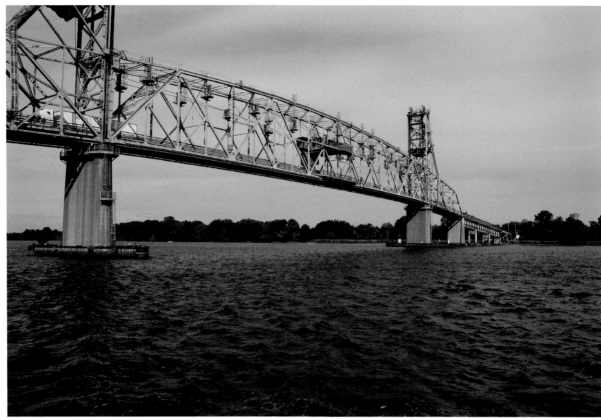

The Burlington-Bristol Bridge connects Burlington, New Jersey, with Bristol, Pennsylvania (home of the "Bristol Stomp"); photographed from the Burlington side of the river.

the ice to establish London and Yorkshire neighborhoods, named for their respective homes in England," Alexander said. "For 200 years, the river made Burlington a rich port that shipped raw materials and early American-manufactured goods out and brought in imports from the around the world."

Burlington had hucksters' markets at the foot of High Street, ferries that took people across to Bristol, Pennsylvania, and steamships destined for Philadelphia and Burlington Island's amusement park that burned down around 1930. It was about that time the Burlington-Bristol Bridge was erected, effectively killing the steamship industry in the area, Alexander said, adding that the Delaware River no longer has much economic impact on Burlington.

Burlington has been in economic decline for a number of years, but it is transforming into a historic and cultural center with related destination businesses, such as restaurants and entertainment venues on the river. Alexander

said a developer has started the chain reaction, and the city now anticipates a boom. "In a short time, you may see the Historical Port City of Burlington rise from its ashes into a marina town...historical district, artist enclave, and charming brick-sidewalk downtown used extensively by light-rail tourists," he said.

Burlington residents like their boats, and Burlington has two public boat ramps. "The

trade in boat permits is brisk and includes Pennsylvanians and out-of-county residents," Alexander said, adding that the tall ship *Meerwald*, New Jersey's official tall ship, docks in Burlington once or twice a year.

City officials believe the river is getting much cleaner in their area.

"We have river watchers who monitor three levels of insects [delicate, hardy, and very hardy] to determine environmental health," Alexander said. *"We are currently protesting a proposed pharmaceutical hazardous waste incinerator project right across the river in the former [industrial] site that is actually closer to Burlington than to most of Bristol Township, [Pennsylvania] where it would be sited. It will generate 2,000 pounds of particulate with dioxins…and other unknown carcinogens and toxic materials."*

Alexander said his parents always told him not to go into the river.

"But my father and uncles canoed and swam in the river in Beverly before the 1950s, and my Italian grandfather reportedly caught eels down the street and had them in a frying pan an hour later. I have eaten catfish and ducks from the river, but not lately," he said. *"My father spoke fondly of shad roasts in the '30s and '40s at the Red Dragon Canoe Club in Edgewater Park, where they would have shad fests when the shad were running in April."*

The Coast Guard Cutter *Capstan*, a sixty-five-foot ice-breaking tugboat home ported in Philadelphia, breaks ice on the Delaware River near the Burlington-Bristol Bridge in January 2014. The *Capstan* crew worked to help prevent flooding and maintain navigable waterways during that particularly harsh winter. *US Coast Guard photo by Petty Officer 3rd Class Cynthia Oldham.*

Bristol, Pennsylvania

"Welcome Friend" is the motto of Bristol in Bucks County, twenty miles from Philadelphia. The town is connected to Burlington, New Jersey, by the Burlington-Bristol Bridge across the Delaware River. Samuel Clift founded Bristol in 1681 and received a grant from the governor of New York that became effective with William

Penn's charter from King Charles II of England. The town was first called Buckingham, and, following English tradition, the county became known as Buckinghamshire, later changed to Bucks County, as it is known today. The "Welcome Friend" sign that still stands in Bristol was first hung in 1824 to greet the Marquis de Lafayette on his farewell tour of America (www. bristolhistory.org).

Bristol also is known as the place that gave birth to the 1961 popular hit song "Bristol Stomp," by a Philadelphia pop group called the Dovells. Teenagers all over the United States were doing a dance called "The Stomp," and the "Bristol Stomp" refers to the popular firehouse dances of the day, in this case the weekly dance at Bristol's Good Will Hose Company. Weekly firehouse dances weren't unique to Bristol—they were popular all over the Philadelphia and Southern New Jersey area ("South Jersey" to the locals). My friends and I in South Jersey didn't have to cross the river to do the "Bristol Stomp"; we hardly ever missed a Saturday night at the firehouse in Mount Holly, New Jersey. But Bristol is the only town to have such a big hit song named for it.

Riverton, New Jersey

The Riverton Yacht Club at Riverton, New Jersey, has served the tri-state area of Pennsylvania, New Jersey, and Delaware since 1865.

The Delaware River has been home to the Riverton Yacht Club since it was organized in 1865. "It is quite active with members from the tristate area (New Jersey, Pennsylvania, and Delaware), who race on Wednesday evenings during the late spring to early fall," said Riverton Mayor William C. Brown. "It was originally built as a paddle wheel steam boat landing. It sustains itself through memberships, boat storage, and as a catering venue during warm summer nights. Also on the Fourth of July, when we have the best parade around, the day ends with a traditional boat race, made up of makeshift boats. Thousands gather along the shoreline to watch and enjoy the lawn parties."

The Fourth is quite a festive event. "Starting at the yacht club, the parade moves through town to our park where we have traditional events such as a grease pole, three-legged races, camel rides, a petting zoo, and a dog show," Brown said. "Then we move to Elms Terrace for our downhill race, which consists of homemade boxcars. Then it's on to the yacht club. The whole town is a festival. The tradition began in 1897."

Brown said the environmental health of the river where it passes by Riverton is excellent, "a far cry from what it had become some years ago when there was a constant flow of cargo ships almost every day. Now it is only one every few days, usually during the late evening. Every town along the river maintains a high level of pollution control, especially since we all have our own sewage treatment plants. Riverton was founded by several prominent Philadelphians for summer homes. I believe that it was the first planned community in America. It was home to the founding family of the Campbell's Soup Company, the man who developed the drive-in movie concept, and one of the organizers of the American Legion."

Riverton is a quiet little borough of less than 3,000 people, and is a mile and a half from major highways. "It's one big neighborhood of wonderful, friendly people," Brown said.

Riverside, New Jersey

Riverside, population 8,000, has been a township since 1895, although historians point to 1851 as the actual beginning of a resort town called Progress on the site. Named for its location along the Delaware River, the township is on the northern side of the confluence with Rancocas Creek, which forms a natural boundary with neighboring Delanco. Numerous marinas thrive in this little community, three of them in a naturally secluded inlet called Dredge Harbor, just off River Road.

Delanco, New Jersey

Delanco Township is one of those sleepy little villages that changes little over time. Delaware Avenue still has its stately homes and mansions overlooking the river, and Rancocas Avenue still has its more moderate homes overlooking Rancocas Creek.

One of those Delaware Avenue mansions is the Gregorian-style Zurbrugg Mansion, constructed in 1910 as the home of Swiss-born industrialist Theophilus Zurbrugg. A watchmaker by trade, Zurbrugg built a successful watchcase factory in neighboring Riverside. When he died in 1912, he left a substantial gift to build Zurbrugg Hospital in Riverside, which was demolished in 2014. It was the birthplace of my youngest daughter, Jennifer. Today, Zurbrugg Mansion is as stately as ever and is used as housing for senior citizens.

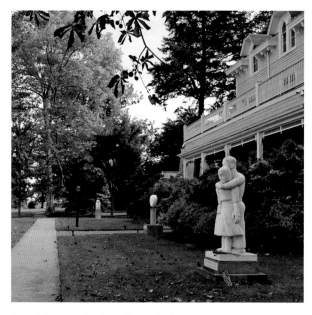

A sculpture on the front lawn of a home at Delanco, New Jersey, commemorates the events of September 11, 2001.

A well-worn piece of Delaware River driftwood rests on a rock at Delanco in this 1972 photo.

Zurbrugg Mansion faces the river on Delaware Avenue in Delanco. Now a care facility for senior citizens, the mansion was once home to industrialist Theophilus Zurbrugg.

The Rancocas Creek at Delanco.

The drawbridge across the Rancocas that separates Delanco from Riverside is still there. Mothers still walk their babies in strollers across the bridge into Riverside to shop, just as my wife did more than forty years ago. The most significant change in Delanco in those forty years is a new railroad bridge across the Rancocas to accommodate New Jersey's high-speed light rail line.

But Delanco almost didn't get its new rail bridge. On April 5, 2001, while the bridge was under construction, its arched span fell over into the creek. The accident caused no serious injuries, but it disrupted rail traffic until officials could engineer a remedy. In a carefully choreographed repair operation timed to coincide with rising tides, construction crews on July 27, 2001, repositioned the fallen span upright. Construction was completed in 2003. Once again, freight trains could cross the Rancocas Creek smoothly, as could River Line

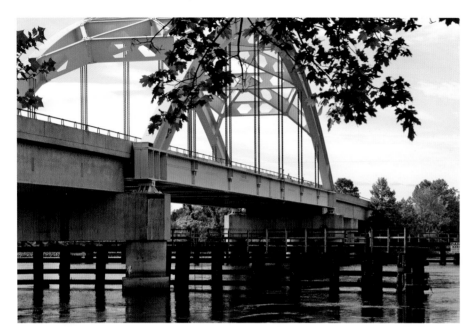

A light rail bridge crosses the Rancocas Creek at Delanco, connecting Delanco with Riverside, New Jersey.

A small marina is visible from the Delanco-Riverside Bridge over the Rancocas Creek at Delanco not far from where the Rancocas joins the Delaware River.

light rail passenger trains beginning in 2004. Passengers can board those trains at a station on Rhawn Avenue.

Delanco's population is just over 4,000, and the township sits at the confluence of the Delaware River and Rancocas Creek (formerly Rancocas River). It was originally named Del-Ranco or Delaranco as an abbreviation for the two rivers. The official name changed to Delanco Township in 1926.

Just two miles from Northeast Philadelphia is Hawk Island Marina on Rancocas Avenue, at the mouth of the Rancocas Creek where it empties into the Delaware River. The owners of the marina have expressed their commitment to sound environmental policies and providing a safe recreational experience through their boating classes. More information about the marina is on its website at www.hawkislandmarina.net.

Workers lower a boat into Dredge Harbor Marina on the Delaware River at Riverside, New Jersey.

Hawk Island Marina on the Rancocas Creek is at the confluence with the Delaware River, Delanco, New Jersey.

Palmyra, New Jersey

Palmyra is a small borough of more than 7,000 residents at the confluence of the Delaware River and Pennsauken Creek. It sits on ground that was once the northern border of New Sweden, settled in the late 1600s. The first railroad came to the town in 1834, when the Camden and Amboy Railroad built a station there. With rail and steamboat access to Philadelphia, the area experienced a real estate boom along the river. Initially named Texas, in honor of that state's 1845 admission to the Union, it was later renamed Palmyra after a historic trading center in Syria. By the 1890s, thanks in part to the 1876 Centennial Exposition in Philadelphia, Palmyra's population had reached 2,000, and its economy was thriving with factories producing cut glass, washing machines, hosiery, and metal castings.

Palmyra Nature Cove opened in 1999 along the banks of the Delaware. The 250-acre park offers educational programs and hiking trails, and serves as a bird sanctuary with tidal marshland providing habitat to more than 200 species of birds. Also hugging the Delaware is Palmyra Harbour, a 500-unit

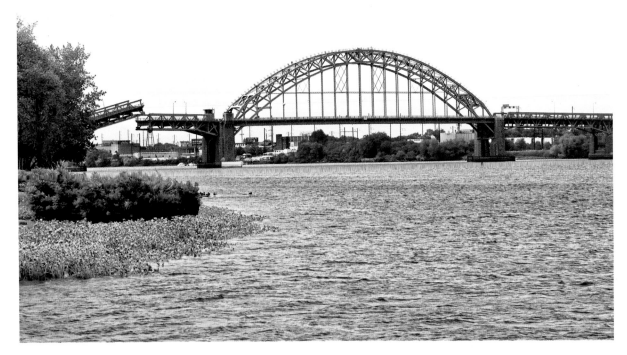

A Canada goose invades the territory of gulls perched on an iron fence at a city park in Beverly, New Jersey, on the Delaware River.

The Tacony-Palmyra Bridge over the Delaware River connects Palmyra, New Jersey, with Northeast Philadelphia.

condominium community with an inviting riverfront walking trail.

Palmyra is well known for the bridge that bears its name and connects it with Northeast Philadelphia. The Tacony-Palmyra Bridge, which opened in 1929 to replace a ferry crossing, has been an integral part of the community ever since. Because it's a drawbridge, it is sometimes responsible for traffic jams on both sides of the river. This bridge and the Burlington-Bristol Bridge upriver must open for tall ocean-going vessels headed to or from the bay and ocean.

Palmyra is at the southern tip of the Delaware River Heritage Trail, a project of the Delaware River Greenway Project, which extends northward to Trenton on both sides of the river (www.delrivgreenway.org).

Philadelphia and Southeastern Pennsylvania

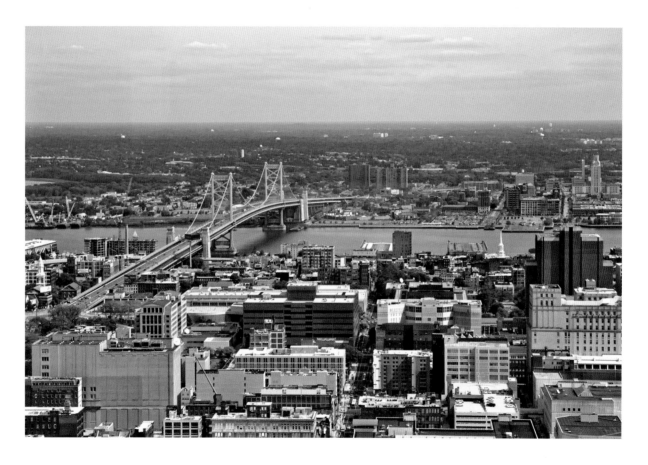

The Benjamin Franklin Bridge over the Delaware River (upper left) and Camden, New Jersey, are visible in this photo, taken from the 43rd floor of Comcast Center in Philadelphia.

In 1682, William Penn founded a city on the Delaware River to be the capital of what was then the Pennsylvania Colony. The American Revolution thrust this emerging national treasure into the role of meeting place for the Founding Fathers, who signed the Declaration of Independence there in 1776. Later, in 1787, the founders got together again to draft the

A warship is under construction at William Cramp & Sons Ship and Engine Building Company shipyard, Philadelphia, Pennsylvania, c. 1905. *Courtesy US Library of Congress.*

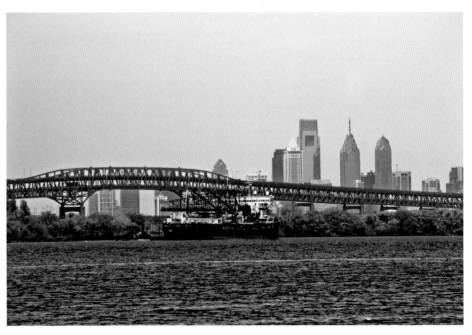

The Center City Philadelphia skyline is visible behind a bridge over the Schuylkill River near where it joins the Delaware, photographed from West Deptford, New Jersey.

Constitution of the United States of America—words that still guide the national government all these years later.

Philadelphia is one of the world's largest freshwater seaports. Its port is in the jurisdiction of the Delaware River Port Authority, along with ports in Camden, New Jersey, across the river, and Wilmington, Delaware. As the fifth-largest city in the United States, Philadelphia is the center of economic activity for Pennsylvania and the Delaware Valley. The city is a tourist magnet for people from all over the world with more than sixty National Historic Landmarks, prominent skyscrapers that form a growing skyline, professional sports, and an inviting park system.

Ranking among the top cities in the nation for arts and culture, Philadelphia attracts about forty million visitors each year that generate about $10 billion in tourism revenue. The Independence National Historic Park, featuring the Liberty Bell and Independence Hall, are certainly at the top of most people's lists of must-see venues when touring this great city.

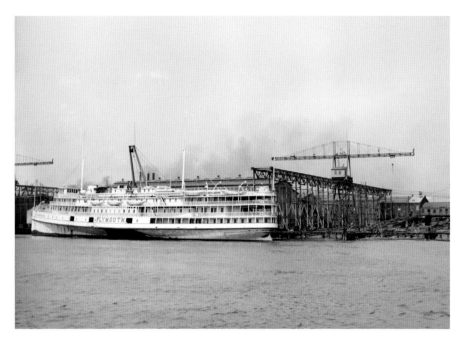

The steamboat *Plymouth* is docked at William Cramp & Sons Ship and Engine Building Company shipyard, Philadelphia, c. 1892–1910. *Courtesy US Library of Congress.*

US Navy monitors are docked at League Island Navy Yard on the Delaware River at Philadelphia. *Courtesy US Library of Congress.*

The Philadelphia Zoo, dating to 1859, is one of the finest in the United States, in a forty-two-acre Victorian garden. The Philadelphia Museum of Art on Benjamin Franklin Parkway, made famous by Sylvester Stallone in the movie *Rocky*, attracts thousands of would-be boxers each year who ascend the steps in Rocky fashion, either for their own satisfaction or to impress their companions. It is, after all, a grueling run to the top, and a statue of Rocky himself awaits them there.

The Franklin Institute on North 20th Street ranks among the most visited sites in Philadelphia. It is one of the oldest science museums in the country with kid-friendly exhibits, an IMAX theater, and the Fels Planetarium. When my children were young and we lived in the area, this and the zoo were their favorite places to visit. Philadelphia offers so many tourist attractions, it might be wise for those planning a trip to the City of Brotherly Love to first visit www.visitphilly.com.

A US Air Force C-141 Starlifter from nearby McGuire Air Force Base, New Jersey, flies over Philadelphia and the Delaware River c. 1993. *US Air Force photo by Ken Hackman.*

Philadelphia's Bridges

The photogenic Philadelphia Water Works at Boathouse Row on the Schuylkill River is a popular tourist attraction.

The Walt Whitman Bridge over the Delaware River into South Philadelphia, photographed from Gloucester City, New Jersey, is one of several commuter bridges into the city.

It is impossible to get into Philadelphia from New Jersey without crossing the Delaware River. Your options are to take any of several toll bridges or a commuter train.

WALT WHITMAN BRIDGE: This two-and-a-quarter-mile-long bridge opened for traffic in 1957. It has seven lanes and connects South Philadelphia with Gloucester City, New Jersey. If you live in New Jersey and are going to a Phillies, Eagles, Sixers, or Flyers game, you would most likely take this bridge. It is named after the poet Walt Whitman, who lived in nearby Camden, New Jersey, near the end of his life.

BENJAMIN FRANKLIN BRIDGE: In 1913, Pennsylvania and New Jersey took steps to enact legislation that would create a formal commission to investigate bridge or tunnel plans to connect Philadelphia with Camden, New Jersey. Both states passed laws in 1919 that created the Delaware River Bridge Joint

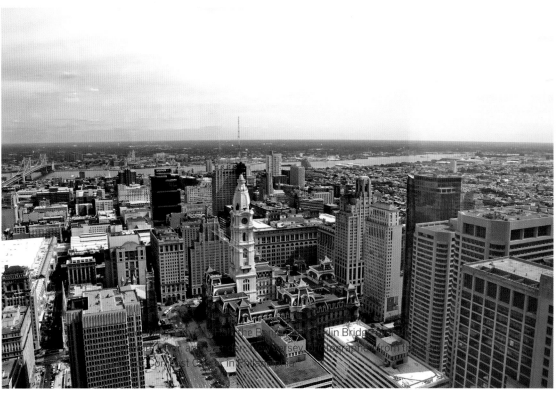

Philadelphia with City Hall, the Benjamin Franklin Bridge over the Delaware River, and Camden, New Jersey, photographed from the 43rd floor of Comcast Center in Philadelphia.

Commission, now known as Delaware River Port Authority. Work on the bridge, first called the Delaware River Bridge and later the Benjamin Franklin Bridge, began in 1922, and the bridge opened on July 1, 1926 (Howard 2009, 8).

BETSY ROSS BRIDGE: This mile-and-a-half-long, six-lane bridge connects Philadelphia with Pennsauken, New Jersey. It was completed in 1976, just in time for the US Bicentennial. Named for the woman who is credited with creating America's first flag, this was the first automotive bridge in the United States named for a woman.

TACONY-PALMYRA BRIDGE: This is one of two bridges operated by the Burlington County Bridge Commission. It connects Northeast Philadelphia with Palmyra, New Jersey. Because this is a drawbridge, which must open to permit ocean-going ship traffic to pass under it, vehicular traffic on both sides grinds to a halt when the bridge opens.

Two other bridges cross the Delaware to serve Philadelphia commuters, one just north of the city and one to the south. The Burlington-Bristol Bridge connects Burlington, New Jersey, with Bristol, Pennsylvania. Like the Tacony-Palmyra Bridge, this one is a drawbridge operated by the Burlington County Bridge Commission. The Commodore Barry Bridge, named after Revolutionary War hero John Barry, connects Chester, Pennsylvania, with Bridgeport, New Jersey. It is one of four bridges operated by the Delaware River Port Authority, along with the Betsy Ross, Walt Whitman, and Benjamin Franklin bridges to the north.

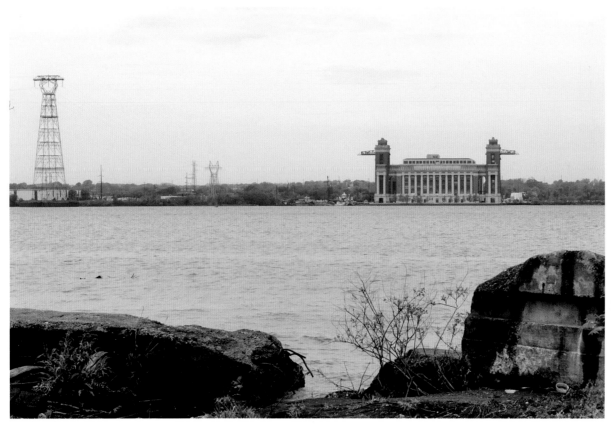

This is all that's left at the site of the Chester Ferry, which was replaced by Commodore John Barry Bridge in 1974. Across the river is the Chester Waterside Station of the Philadelphia Company, which dates to 1916.

Chester, Pennsylvania, a city of about 34,000 people, sits on the Delaware River between Philadelphia and Wilmington, Delaware. It was settled in 1644 by Swedes, who first named it Finlandia, then later Upland. The name changed to Chester after the English city of the same name in 1682, the year in which

An 1846 watercolor painting by Michael Seymour depicts sailboats and a rowboat near the Chester Wharf twenty miles below Philadelphia on the Delaware River. *Courtesy US Library of Congress.*

Old boats rest on the shore of the Delaware River at Chester, Pennsylvania, c. 1938. *Photo by Paul Vanderbilt, Courtesy US Library of Congress.*

An ocean-going cargo vessel loads at the Port of Philadelphia, photographed from Gloucester City, New Jersey.

William Penn arrived and acquired the settlement as a safe place for Quakers. Chester is the oldest city in Pennsylvania, and the site of five nationally registered historic places, including the Chester Waterside Station of the Philadelphia Electric Company, a notable landmark on the riverbank.

Wilmington, Northern Delaware, and Southern New Jersey

Wilmington: State Capital and "Corporate Capital of the World"

A replica of the 1638 sailing ship *Kalmar Nyckel* is ported on the Christina River in Wilmington, Delaware, near the Delaware River and Fort Christina.

Delaware's capital of seventy-two thousand people is about halfway between New York City and Washington, District of Columbia. Anyone who lives anywhere on the East Coast can easily access Wilmington via Amtrak's rail line, the nearby Philadelphia International Airport, Wilmington's airport, or a complex and robust system of interstate highways.

City officials boast of Wilmington's reputation as the corporate capital of the world, with more than half of the largest companies and financial institutions in the United States calling the city their corporate home. This was brought about by a state and city tax structure that favors corporate America, and state banking laws enacted in the 1980s.

Wilmington's Attractions

Wilmington has more than 500 acres of parks, including Brandywine Zoo, trails for jogging and hiking, and recreation areas. Arts and culture thrive with theaters, an opera house, and a professional theater group in a new facility on the Christina River, a Delaware River tributary.

Nearby attractions include the Nemours Mansion and Gardens, Winterthur, Hagley Museum, and the beautiful Longwood Gardens at Kennett Square, Pennsylvania. These are legacies of the du Pont family, who made their fortunes in the gunpowder business with the company E. I. du Pont de Nemours (www.ci. wilmington.de.us/residents/cityinfo).

Nemours Mansion was the home of Alfred I. du Pont and his second wife Alicia, for whom he built the house in 1907 on a 3,000-acre plot in Wilmington. The gardens include a "Long Walk" from the mansion to a reflecting pool with more than 100 jets that send water twelve feet in the air. Information about the mansion and gardens, including directions and contact information, is on the website www.nemoursmansion.org.

Winterthur Museum, Garden and Library, with its 175 rooms, was the home of Henry

The New Jersey Coastal Heritage Trail passes through historic Fort Nya Elfsborg. Built in 1643 as part of a settlement known as New Sweden, the original fort is now under water at Elsinboro Point.

Francis du Pont. Galleries, which feature a collection of nearly 90,000 artifacts, are spread throughout the mansion. More information is on the website www.winterthur.org.

The Hagley Museum and Library is another du Pont home on the site of the gunpowder works that E. I. du Pont founded in 1902. Information is at www.hagley.org.

Wilmington was first colonized by the Swedish in 1638, and then the Dutch in 1655.

Just nine years later in 1664, the British arrived and brought stabilization under British rule with Quaker influence. The first developer of the land was Thomas Willing, and the city was named Willington after him. When the king of England issued a charter in 1739, the name changed to Wilmington, for Spencer Compton, earl of Wilmington. The state legislature granted a city charter in 1832 (www.ci.wilmington.de.us).

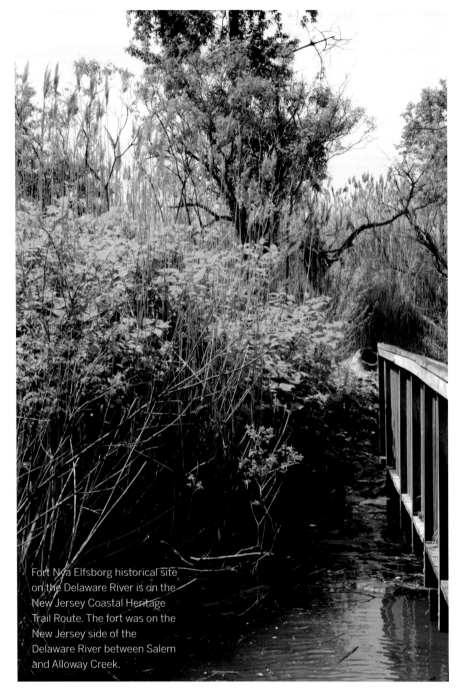

Fort Nya Elfsborg historical site on the Delaware River is on the New Jersey Coastal Heritage Trail Route. The fort was on the New Jersey side of the Delaware River between Salem and Alloway Creek.

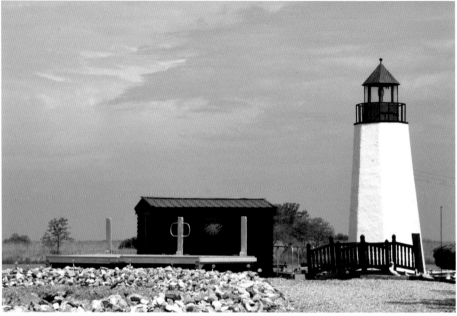

This lighthouse is on private property at Sinnickson's Landing, Elsinsboro Township.

Elsinboro Township, New Jersey, near Elsinboro Point. Scenic Elsinboro Point is in Elsinboro Township, Salem County, New Jersey.

Wilmington, Northern Delaware, and Southern New Jersey

Chesapeake and Delaware Canal

The Bethel Cross marks the site of Bethel Methodist Church, organized in 1771. The building was removed in 1965 due to the widening of the Chesapeake and Delaware Canal (in background), Summit, Delaware.

The Chesapeake and Delaware Canal, as the name suggests, connects the Delaware River with the Chesapeake Bay. It has been in use since 1829.

As its name suggests, the fourteen-mile Chesapeake and Delaware Canal connects the Delaware River with the Chesapeake Bay. Its eastern mouth is Reedy Point, Delaware, and the western point is at Chesapeake City, Maryland. The canal was built by private interests in the 1820s and opened in 1829, when it had only ten feet of water at low tide. The US government purchased the canal in 1919, and the US Army Corps of Engineers expanded it several times. In the 1930s, the Corps of Engineers deepened the canal to twenty-seven feet and widened it to 250 feet. By the 1970s, the channel depth became thirty-five feet and the width increased to 450 feet, which allows it to accommodate oceangoing vessels. The canal is on the National Register of Historic Places and designated as a National Historic Civil Engineering and Mechanical Engineering landmark (www.pennways.com).

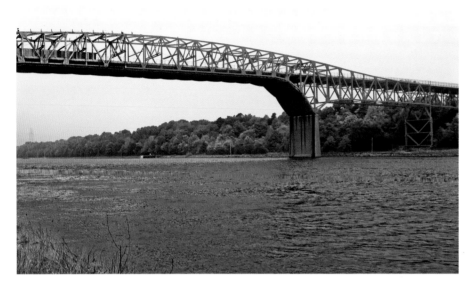

The four-lane Summit Bridge on Route 301 crosses the Chesapeake and Delaware Canal at Summit, Delaware.

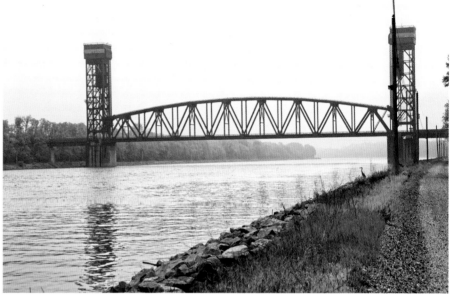

The Chesapeake and Delaware Canal Lift Bridge, owned by Norfolk Southern Railroad, raises its middle span when tall cargo ships need to pass under it on the Chesapeake and Delaware Canal, Summit, Delaware.

Wilmington, Northern Delaware, and Southern New Jersey

The Chester-Bridgeport Ferry

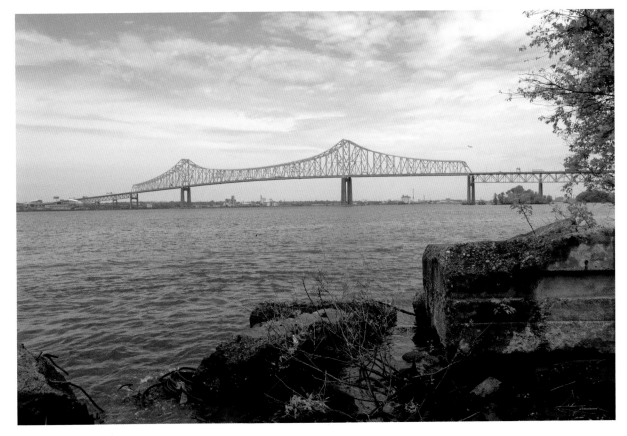

A fisherman tries his luck at the former site of Chester-Bridgeport Ferry at Bridgeport, New Jersey. An oil refinery at Chester, Pennsylvania, is in the background.

The former site of Chester-Bridgeport Ferry at Bridgeport, New Jersey, is a good place to photograph the Commodore John Barry Bridge that replaced the ferry in 1974.

Taking only six minutes to cross the Delaware River between Chester, Pennsylvania, and Bridgeport, New Jersey, this ferry encouraged growth of local businesses on both sides of the river. The ferry first crossed the Delaware in 1930 with two boats: the Chester and the Bridgeport. A third boat, the Delaware, was added in 1935, and the Lackawanna in 1949. The ferry made its last crossing in 1974 when the nearby Commodore Barry Bridge opened. Today, one can stand on the littered remains of the ferry landing in Bridgeport where anglers cast their fishing lines, and view the unpleasant sight of an oil refinery and Delaware County (Pennsylvania) Electric Company on the other side of the river.

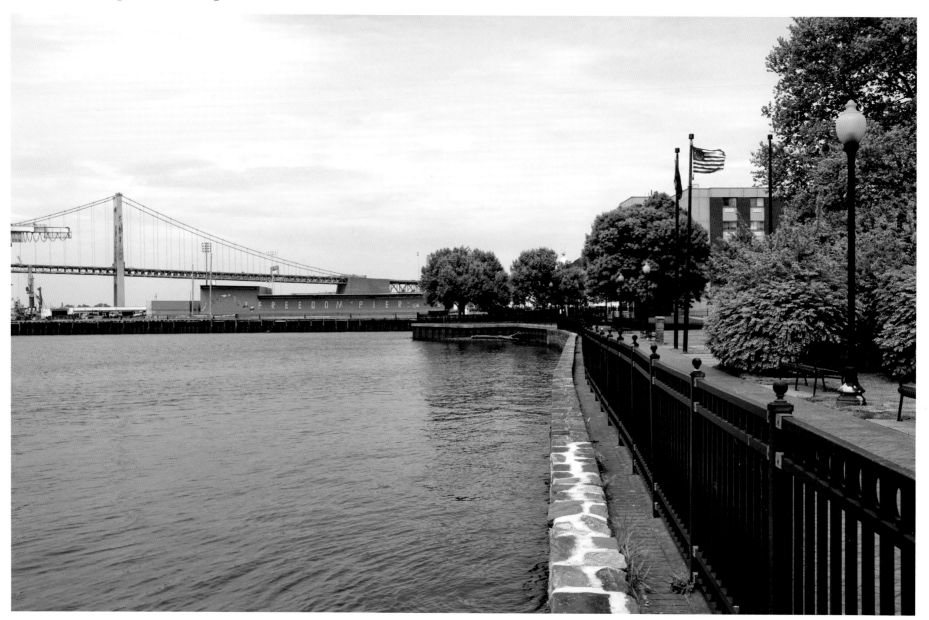

Gloucester City, New Jersey, is directly across the Delaware River from South Philadelphia. Its riverside park area is a good place to view the river and the Walt Whitman Bridge.

Wilmington, Northern Delaware, and Southern New Jersey

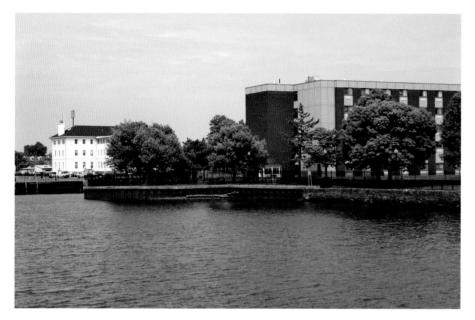

This view of Gloucester City, New Jersey, from Freedom Pier on the Delaware River, shows the riverside park.

A modern gazebo adds charm to the riverside park at Gloucester City.

Gloucester City sits on a bend in the Delaware across the river from South Philadelphia and just south of Camden. Dutch settlers landed here in 1623, and built a fort and trading post. Fort Nassau was built so the Dutch could command the river and prevent traders from accessing the Schuylkill River, whose mouth is about three-and-a-half miles downriver. City officials cannot pinpoint the exact location of the original Fort Nassau, which existed from 1626 to 1651, but they identify it as the first Dutch fortified settlement on the Delaware (www.cityofgloucester.org).

From 1888 to 1890, the Philadelphia Athletics (later the Kansas City Athletics and now the Oakland Athletics) played Sunday baseball games in Gloucester City. The team couldn't play Sunday games in Philadelphia due to blue laws there that prevented business activity on Sundays.

Today, Gloucester City, population 11,000, has one of the finest river walks among Delaware River communities. It provides unique views of the Philadelphia skyline, Walt Whitman Bridge, and the Port of Philadelphia.

A large cargo ship passes Riverside Park, Pennsville, New Jersey, on its way upriver to the Port of Philadelphia.

The twin spans of the Delaware Memorial Bridge connect Delaware with New Jersey. Photo taken at Pennsville, New Jersey.

Pennsville and Fort Mott State Park, New Jersey

The River Park at Penns Grove, New Jersey, is an enjoyable place to stroll along the riverbank.
The Delaware Memorial Bridge is visible in the background.

Fort Mott was built in the late 1800s as part of the defense system for the Delaware River. The structures that still stand there were built in 1896 in preparation for the Spanish-American War. The defense system was designed during the post-Civil War modernization period. Other forts in the system were Fort Delaware on Pea Patch Island and Fort DuPont in Delaware City, Delaware. The three forts became obsolete when Fort Saulsbury was built near Milford, Delaware, after World War I.

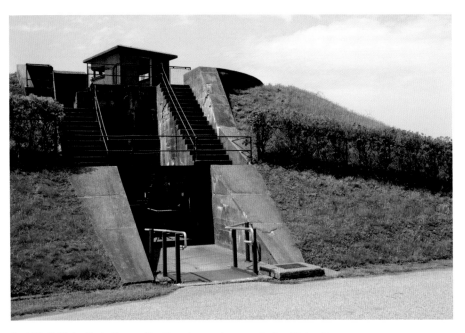

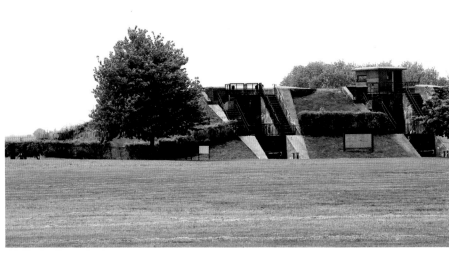

Fort Mott State Park, Pennsville, New Jersey, is named after Major Gen. Gershom Mott, who served in the Mexican and Civil Wars.

Fort Mott was built in the late 1800s as part of the defense system for the Delaware River.

Today, interpretive signs lead visitors through the old batteries. The shoreline offers walking trails and good places to picnic, and the New Jersey Coastal Heritage Trail Welcome Center there has displays detailing Fort Mott's history. New Jersey acquired the historic site in 1947 (www.state.nj.us).

The Delaware City-Salem Ferry, operated by the Delaware River and Bay Authority, transports visitors and tourists to Fort Delaware and Fort DuPont. Schedules and fare information can be found at www.decitysalemferry.com.

The Salem River meets the Delaware just below Supawna Meadows National Wildlife Refuge in Pennsville. Formerly Lower Penns Neck Township, it was renamed Pennsville in 1965.

National Park, New Jersey

Red Bank Landing at National Park, New Jersey, offers a view of the Philadelphia Naval Shipyard and the city's skyline.

US Navy ships and commercial vessels dock at the Philadelphia Naval Shipyard across the Delaware River from National Park, New Jersey.

Tell someone you visited National Park to take some photos, and the response will likely be, "Which national park?" It's confusing, because it's not a national park at all. National Park is the name of a quaint little town in Gloucester County, New Jersey, where one can stand on a river walk at Red Bank Landing and photograph Philadelphia Naval Shipyard on the other side. Its name derives from "National Park on the River," a religious resort there in the 1890s. Only one square mile, the borough is home of the Red Bank Battlefield where the Continental Army under command of General George Washington built Fort Mercer, one of two Revolutionary War forts that were used to block the entrance to Philadelphia. The other was Fort Mifflin on the Pennsylvania side. Fort Mercer was named for Brigadier General Hugh Mercer, who died in 1777 at the Battle of Princeton. In October 1777, 900 Hessian troops under British command attacked Fort Mercer in what is now known as the Battle of Red Bank. In that battle, 600 Continental Army soldiers successfully defended the fort, inflicting heavy losses on the Hessians. National Park became a borough in 1902 (www.nationalparknj.com).

Delaware Bay

The Bay

The days often end with spectacular sunsets over the Delaware Bay at Cape May Courthouse, New Jersey.

The Delaware Bay starts at the junction of the Delaware River and the Alloway Creek, and travels southeastward for fifty-two miles to meet the Atlantic Ocean. Throughout its length, it is the boundary between Delaware and New Jersey, and towns on both sides of the bay are sparsely populated. The bay is an important shipping lane with marshy lowlands on both sides. The mouth of the bay is twelve miles wide at Cape Henlopen, Delaware, and Cape May, New Jersey. The famous Cape May–Lewes Ferry transports vehicles and passengers from one side of the bay to the other (www.britannica.com/place/Delaware-Bay).

The Estuary

The Cape May–Lewes Ferry leaves the dock in Lewes, Delaware, en route to Cape May, New Jersey.

The Delaware Breakwater East End Lighthouse at Lewes lit the way for ships entering the Delaware Bay from the Atlantic Ocean from 1885 until it was deactivated in 1996.

A windy March day doesn't deter fishermen on the pier at Woodland Beach, Delaware, on the Delaware Bay.

An estuary is the lower end of a river where the ocean tide flows in, and where fresh and salt water mix. The Delaware Bay estuary covers more than 3,000 square miles between Delaware and New Jersey. It is a temporary home for more than 100 species of migratory birds, as well as shore birds, waterfowl, raptors, and songbirds. Many are just passing through this stopover on their route between South America and Canada. Wetlands on both sides of the bay provide habitat for green tree frogs and numerous species of rare plants. According to the Nature Conservancy, "residential development, climate change, overfishing, and invasive species have been causing increasing amounts of stress to the landscape," on both sides of the bay. Water quality is suffering from increased sedimentation in the area due mainly to residential development. The Nature Conservancy and other conservation groups consider oyster reef habitat areas in the bay a conservation priority (www.nature.org).

The estuary extends northward beyond the bay all the way to the falls in Trenton, a total of more than 130 miles. Approximately eight million people live in the estuary's watershed. Oysters, crabs, terrapins, ducks, and humpback whales live in the estuary, which is also the home of the world's largest horseshoe crab population. Thirty-five percent of the region's threatened and endangered species live in more than a million acres of the estuary's wetlands.

The Delaware estuary sees heavy industrial use. It serves the world's largest freshwater port and second largest petrochemical refining center in the United States. Seventy percent of the oil that arrives on the East Coast passes through on huge cargo ships, exposing the area to the risk of oil spills. Although the river's water quality has improved since the passage of the Clean Water Act in 1972, Delaware Riverkeeper officials say nitrogen and phosphorus continue to create pollution problems in many tributaries. Because of toxic contamination, New Jersey, Pennsylvania, and Delaware have issued advisories for consumption of locally caught fish (www.delawareriverkeeper.org).

These pilings are all that remain of a washed-out pier at Fowler Beach, Delaware, on the Delaware Bay.

The salt line, or that area where water reaches a certain chloride concentration, fluctuates along the tidal Delaware River as stream flows increase or decrease, diluting or concentrating chlorides in the river. The Delaware River Basin Commission uses a seven-day average of salinity in the water as an indicator of salinity intrusion in the estuary. When salty water moves upriver it increases corrosion-control costs for industry and can raise treatment costs for public water suppliers.

Five reservoirs release freshwater into the river at various points to help repel the salt-laced water, or push it back downriver. New York City owns three of the reservoirs in the Catskill Mountains in New York State—Pepacton, Neversink, and Cannonsville. When full, they hold nearly three billion gallons of water. Reservoirs along the Schuylkill and Lehigh Rivers hold nearly twenty billion gallons when full.

Lewes, Delaware

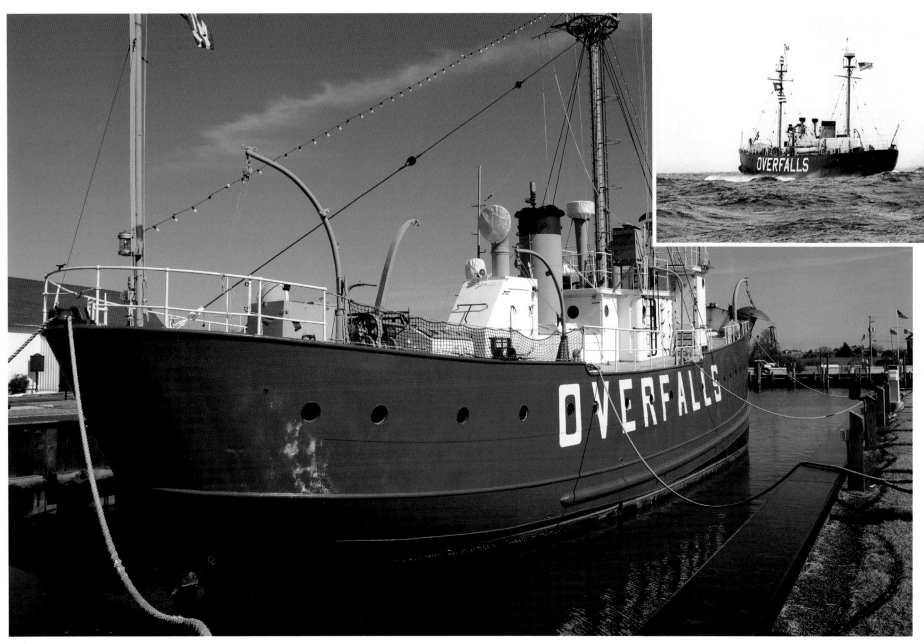

The Delaware and Rehoboth Canal at Lewes is home to the lightship *Overfalls*, one of only seventeen remaining lightships out of 179 built from 1820 to 1952. Designated a National Historic Landmark in 2011, it is one of seven lightships still open to the public.

The lightship *Overfalls,* seen here at sea, was built in 1938 and decommissioned in 1972. *Undated US Coast Guard photo.*

Marinas dot the shoreline of the Delaware and Rehoboth Canal at Lewes.

Charter boats *Thelma Dale V* and *Keen Lady IV* dock at the Delaware and Rehoboth Canal, Lewes.

Known as "The First Town in the First State," Lewes is home to the world-famous Cape May-Lewes Ferry. The town was founded by the Dutch in 1631 to create a whale-oil colony, and offers gorgeous views of the coastline. They built a fort called Swanendael, which means "valley of the swans." A misunderstanding between the Dutch colonists and the Native Indians led to the fort's destruction and massacre of the colonists.

Lewes is the East Coast port of call to a large fleet of charter fishing boats and the site of the University of Delaware College of Marine Studies. The people who live there take great pride in their heritage. Lewes is at Cape Henlopen, where the Delaware Bay meets the Atlantic Ocean. Within a short walking distance in the historic district of Lewes are many museums, inns, restaurants, and specialty shops. The Delaware River has a major impact on the local Lewes economy, said Mayor Ted Becker, who owns and operates a marina on the Lewes-Rehoboth Canal:

The good overall environmental health of the river and bay have helped make the area a popular recreation destination, according to the mayor:

"The recreational value of the river and bay is tremendous as both residents and visitors enjoy many forms of fishing, boating, water sports, and more recently ecotourism," Becker said. *"The open space along the bay in this area provides excellent access for these activities."*

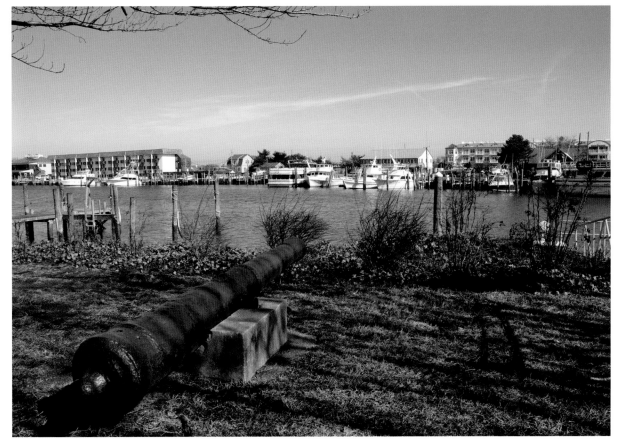

A cannon protects Lewes at the 1812 Memorial Park on the Delaware and Rehoboth Canal.

"The Delaware River and the bay provide significant employment opportunities for local residents whether it be the river pilots, marine research conducted by the University of Delaware or others, maritime history, water recreation, or fishermen. Lewes residents benefit from these many varied forms of employment as well as the connectivity to the ports of Wilmington and Philadelphia."

Sparsely populated Port Mahon, Delaware, on the Delaware Bay offers a pier for local fishermen.

Gulls occupy pier pilings at Port Mahon, Delaware, on the Delaware Bay.

A derelict boat rests near the Delaware Bay at Woodland Beach.

Cape Henlopen State Park contains 3,000 acres of beautiful beaches, bird sanctuaries, a nature center, areas for surf fishing and swimming with a modern bathhouse offering showers and changing rooms, and nature trails. The park is home of the "Great Walking Dune" and a WWII observation tower. It also has a quarter-mile-long pier with access to the Delaware Bay. For more information about the park, call (302) 645-8983 (www.lewes.com).

More than 130 species of birds and aquatic life can be found in the estuary surrounding the DuPont Nature Center on the Delaware Bay at Milford, Delaware.

A marker and jetty at Milford on the Delaware Bay provide marine navigation and shoreline protection.

This Delaware Bay lighthouse is on the grounds of Supawna Meadows National Wildlife Refuge in Salem County, New Jersey.

A sculpture stands near the beach at Woodland Beach.

The Partnership for the Delaware Estuary is a nonprofit advocacy group, and one of twenty-eight congressionally designated programs working to improve the environmental health of estuaries. Its mission is defined on its website: "The Partnership for the Delaware Estuary, a National Estuary Program, leads science-based and collaborative efforts to improve the tidal Delaware River and Bay, which spans Delaware, New Jersey, and Pennsylvania" (www.delawareestuary.org).

Rancocas Creek

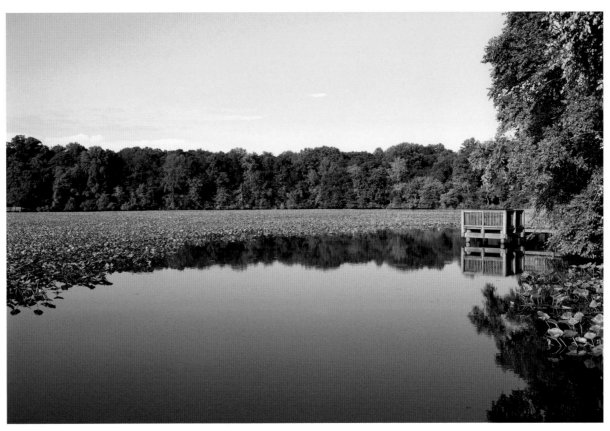

A perfectly calm morning on the Rancocas Creek reflects a nearly cloudless sky at historic Smithville Park, Eastampton Township, New Jersey.

Known as Rancocas River in another era, the Rancocas Creek flows through much of South Jersey, mainly in Burlington County, and is known by all of the residents. The main stem of the creek is only about eight miles long, beginning in Hainesport and flowing west-northwest, emptying into the Delaware at Riverside on its south bank and Delanco on the north. However, the main stem is by no means all there is to this picturesque, flowing water.

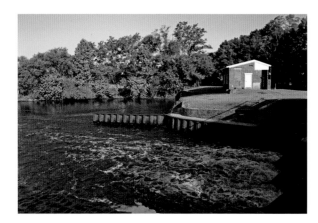

The Mill Dam at Mount Holly is an idyllic setting for recreation.

The Rancocas Creek is channeled through this section of downtown Mount Holly, much like an aqueduct.

Two branches meet at Hainesport, each fed by tributaries that wind through the area. The North Branch and South Branch are the two main tributaries, but several other branches drain into those two. The watershed is 360 square miles, the largest in this part of New Jersey.

The Rancocas is tidal for about fifteen miles, including the entire length of the main stem to the dam at Mount Holly on the North Branch, Vincentown on the South Branch, and Kirby's Mill on the Southwest Branch (a tributary of the South Branch).

Rancocas State Park

Rancocas State Park in New Jersey's Westampton Township is the perfect setting for hiking, picnicking, and observing nature. The Audubon Society runs a nature center in the park and sponsors wildlife programs and guided walks on nature trails. The Powhatan Indians, whose ancestors occupied the site in the 1600s, lease a portion of the park, which contains a replica of an ancient Indian village. An annual event features Powhatan music, performances, and crafts. More information is available at www.stateparks.com.

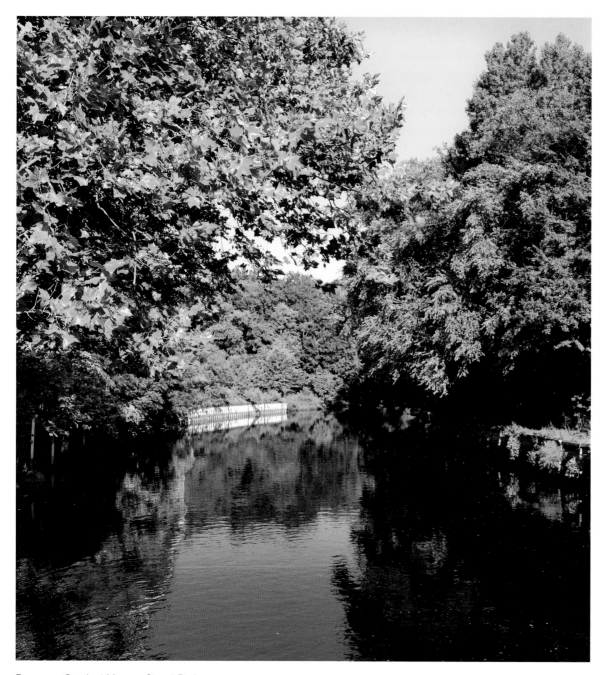

Rancocas Creek at Monroe Street Park.

Timbuctoo

Yes, there really is a Timbuctoo, and it was settled along the North Branch of the Rancocas Creek in the mid-1820s by African Americans. For the first time in the United States, African Americans could own land, build homes, and establish churches, schools, and businesses. The site, in modern-day Westampton Township, was a three-acre village near the creek. Some of the larger lots are still occupied by descendants of the original settlers, while the village is now an open field with no standing structures. A Timbuctoo archeological project is looking for information about the houses, the use of the property, and the diets and personal property of the inhabitants. For more information, visit the website www.westampton.com/timbuctoo.

Smithville Park

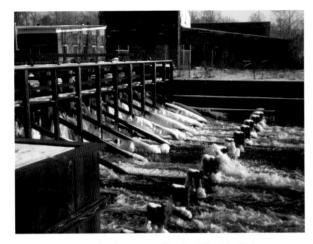

This mill dam on the Rancocas Creek at Smithville in Eastampton, New Jersey, sometimes freezes in winter.

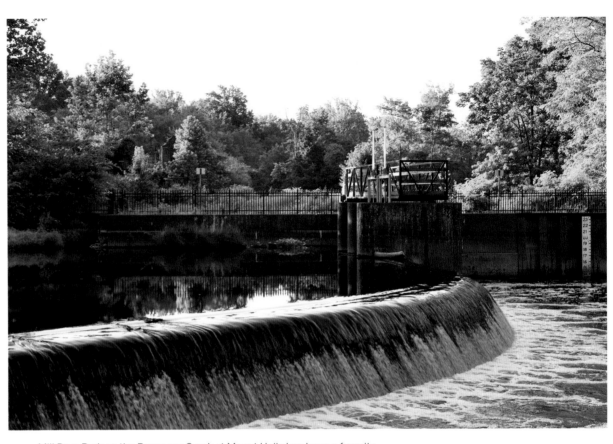

Mill Dam Park on the Rancocas Creek at Mount Holly has been a favorite recreational site for more than a century.

In all of my travels for this book, historic Smithville Park on the Rancocas Creek in Eastampton Township is perhaps my favorite. Never mind that as a teenager I lived in the township, swam in the creek, and played baseball there, this place abounds with beauty and historical significance. The Burlington County Parks system calls this 300-acre park its centerpiece. Smithville Historic District, which grew from a typical small mill operation on the creek to a major industrial plant, is on the National Register of Historic Places. From the 1860s to the 1920s, hundreds of workers lived there and produced woodworking machinery, a bicycle railroad between Smithville and Mount Holly, and high-wheeled bicycles (www.co.burlington. nj.us/948/Historic-Smithville-Park).

Lumberton

Known as Lumbertown in earlier times, Lumberton is another historic site on the Rancocas Creek in Burlington County, New Jersey, and another of my favorite places. It is where my wife and I first lived as a married couple in what had been a historic hotel called the Boxwood Lodge, dating to at least 1910, and where both of my daughters were married in a Baptist church. Although the area has experienced considerable growth over the last forty years, the main village is as quaint and charming as ever.

The village can trace its history to 1683 when Robert Dimsdale bought land from William Penn

The wrought iron fences along the Rancocas Creek at Mill Dam Park were likely manufactured in nearby Smithfield on the Rancocas.

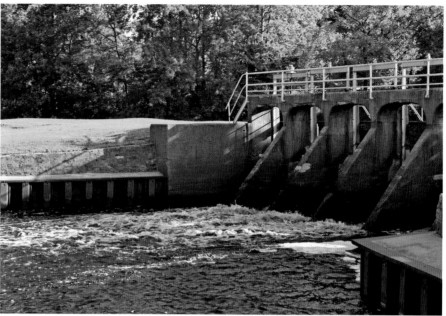

The Rancocas Creek Association has been working with local government officials to prevent destruction of the old Mill Dam in Mount Holly, as proposed by the US Army Corps of Engineers.

Hiking trails along the Rancocas Creek in Mount Holly offer quiet settings for taking in the area's natural beauty.

on the north side of the Rancocas, and later set up a sawmill on the land. Lumberyards and sawmills in the area shipped their goods to Philadelphia and other places on boats and barges on the Rancocas Creek. It was incorporated as a town in 1860 (www.lumbertontwp.com).

The Rancocas Conservancy

The old railroad bridge connected Delanco, New Jersey (foreground), with Riverside, c. 1971.

Delanco, New Jersey, is a quiet little village at the confluence of the Rancocas Creek and Delaware River.

STOP HERE WHEN GATES ARE DOWN

The Rancocas Conservancy is the leading land trust in the Rancocas Creek watershed. It maintains ten preserves and is responsible for the preservation of more than 1,000 acres of land. The group promotes preservation and protection of the watershed through land acquisition and environmental education.

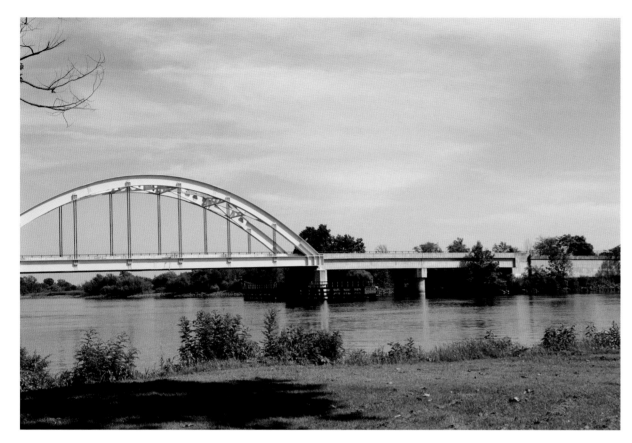

Mill Dam at Mount Holly, New Jersey, controls the water level of the Rancocas Creek between Mount Holly and Smithville.

This railroad bridge crosses the Rancocas Creek connecting Delanco (foreground) with Riverside.

The group also works with landowners to help design preservation methods.

According to its website, the Rancocas Creek Conservancy's mission is "to preserve, protect, and enhance the ecological and cultural integrity of the Rancocas Creek watershed and its environs" (www.rancocasconservancy.org).

Wissahickon Creek

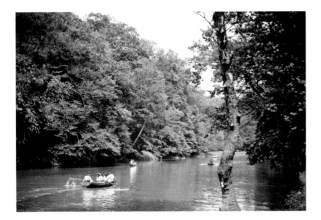

Canoeists row on the Wissahickon Creek in Philadelphia, c. 1900. *Courtesy US Library of Congress.*

The Wissahickon Creek winds through much of the Philadelphia area for twenty-three miles before emptying into the Schuylkill River not far from its confluence with the Delaware. The creek is a major attraction to Philadelphia's beautiful Fairmount Park and Wissahickon Valley Park. Friends of the Wissahickon is a nonprofit advocacy group that works with the Philadelphia Parks and Recreation Department on restoration, conservation, and watershed management issues. The organization's mission is to preserve the natural beauty and wilderness of the valley and stimulate public interest (www.fow.org).

Lehigh River

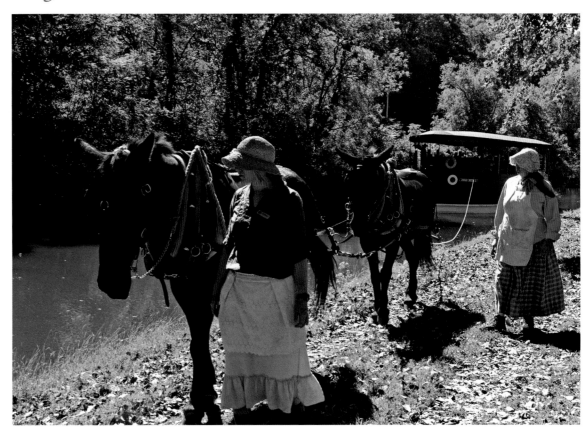

Daphne Mayer and Sue Francisco walk mules along a towpath to move a canal tourist boat on the Lehigh Canal at the National Canal Museum, Hugh Moore Park, Easton, Pennsylvania.

The Lehigh River flows slightly more than 100 miles entirely within Pennsylvania until it reaches the Delaware River at Easton, just across the Delaware from Phillipsburg, New Jersey. Pennsylvania cities that embrace the Lehigh are Scranton, Lehighton, Allentown, Bethlehem, and Easton. Pennsylvania's Department of Conservation and Natural Resources has designated part of the Lehigh, including several of its tributaries, a Pennsylvania Scenic River.

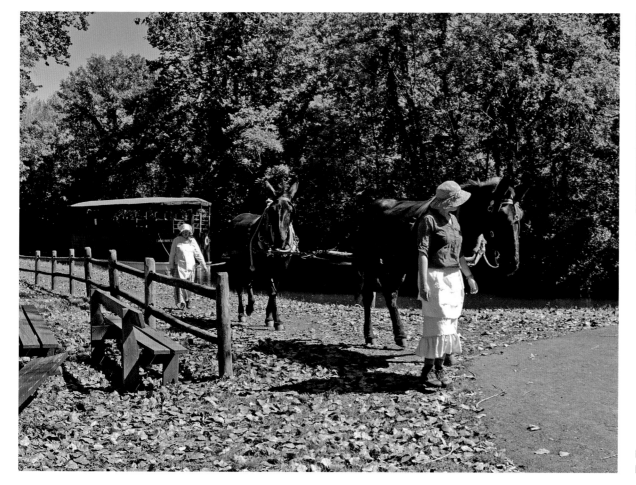

A canal boat makes its way along the towpath of the Lehigh Canal, Easton.

Mules belonging to the National Canal Museum at Easton are well cared for.

The Lehigh River begins in the area of Pocono Peak Lake near Gouldsboro, Pennsylvania, at an elevation of 2,200 feet above sea level. It flows just over 100 miles to the Delaware River, dropping nearly 1,000 feet along the way. The watershed occupies about 1,300 square miles. During the seventeenth and eighteenth centuries, the Lehigh was referred to as the west branch of the Delaware River.

The Lehigh Navigation Canal, finished in 1829, used twenty-eight dams and eighty-one locks to change elevation more than 900 feet. The canal carried natural resources like coal, slate, and timber to markets downstream. After 1834, the canal became part of a larger system of canals, including the Morris Canal, that linked it to New York, and the Delaware Canal, which transported goods to Philadelphia. An 1862 flood destroyed most of the dams and locks in the upper section, and they were never rebuilt. The canal operated until 1932.

The canal lives on as a tourist attraction in West Easton, Pennsylvania, at the National Canal Museum in the Hugh Moore Park, which has the river on one side and the canal on the other. Here is where visitors can experience a ride on a mule-towed passenger boat along the canal. Women in period dress guide the mules while onboard crew inform guests about the canal's history.

The Lehigh River once provided a vital transportation link for America's iron industry. Between 1850 and 1880, about one-quarter of iron production in the United States came from this region. Steel from the Bethlehem Steel plant was used in many of America's landmarks, including New York's Empire State Building and California's Golden Gate Bridge. The plant used more than one million gallons of water a day in processing steel.

Officials of the nonprofit Lehigh Valley Water Suppliers say that, thanks to pollution control efforts, the Lehigh has better water quality today than it has in more than 175 years. The river and its banks are home to a

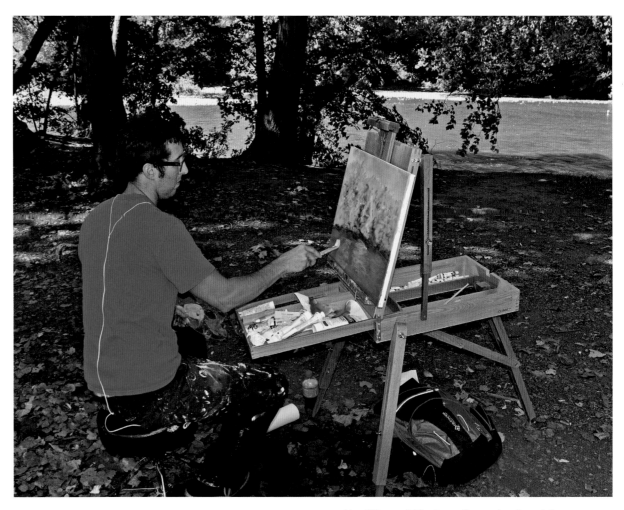

Alex Bilbow of Allentown, Pennsylvania, paints a scene on the Lehigh River at Hugh Moore Park in Easton.

wide variety of plant and animal species. Osprey, great blue heron, beaver, muskrat, killdeer, turkey, whitetail deer, hawks, and bald eagles have been seen along the river (www.lvwater.org).

Schuylkill River

The Schuylkill River is about 135 miles long and flows from the Pocono Mountains to Philadelphia, entirely in Pennsylvania. In 1682, William Penn chose the confluence of the Schuylkill and Delaware Rivers as the place to found the city of Philadelphia. A river trail system follows the Schuylkill along several stretches of the river. As of 2015, more than sixty miles of the proposed 130 miles of trail had been completed, including a nearly thirty-mile section from Philadelphia to Phoenixville. The trail is for hiking, jogging, biking, and other recreational uses. Trail information is on the website www.schuylkillrivertrail.com.

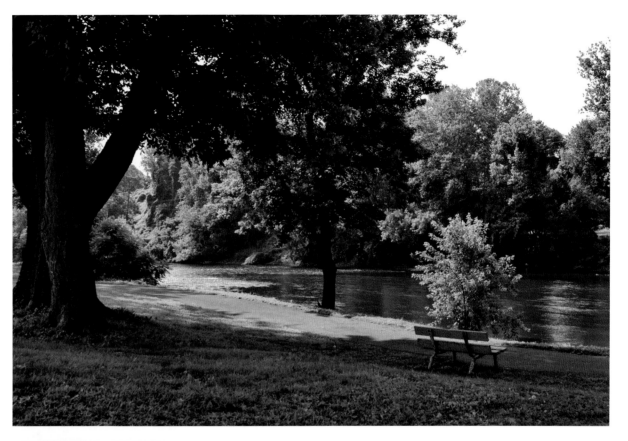

Heritage Park is a scenic setting on the Schuylkill River at Reading, Pennsylvania.

A hike down a long, steep path from Klapperphall Road in Reading rewards hikers. with a view of the Schuylkill River. The return trip uphill is not for the weak.

Bathers cool off in the Schuylkill River on a hot summer day in Reading.

The Tributaries

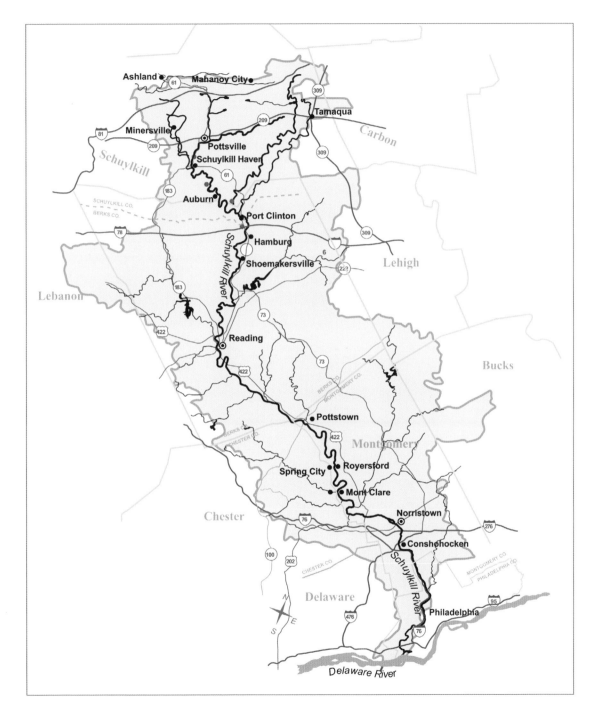

Downtown Reading can be seen from the Bertolet Fishing Dock on the Schuylkill River at West Reading.

Sometimes called the "Revolutionary River," the Schuylkill River Heritage Area includes historic Valley Forge and several other Revolutionary War sites. The cities of Reading and West Reading have a Schuylkill trail system that is easily accessible and quite scenic, even in the urban areas. The trail in Reading offers a combination of tranquil waters and mild rapids.

Map © 2003 courtesy Schuylkill River National and State Heritage Area.

A major tributary of the Delaware River, the Schuylkill River flows gently between Reading and West Reading.

The Schuylkill River at Reading becomes white-water rapids as it passes over a rocky stretch.

Lackawaxen River

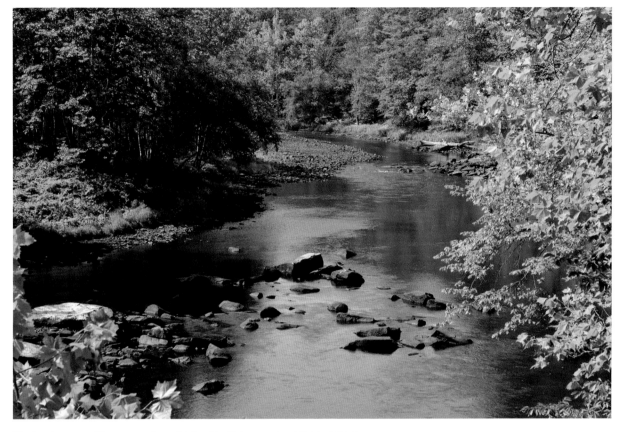

The Lackawaxen River near where it joins the Delaware provides excellent recreational fishing and stunning views.

The Lackawaxen River joins the Delaware River about a mile from this point at Lackawaxen, Pennsylvania.

"Winding among the Blue Hills of Pennsylvania there is a swift amber stream that the Indians named Lack-a-wax-en. The literal translation no one seems to know, but it must mean, in mystical and imaginative Delaware, 'the brown water that turns and whispers and tumbles.' It is a little river hidden away under gray cliffs and hills black with ragged pines. It is full of mossy stones and rapid ripples" (Grey 1928, 15).

The thirty-mile-long Lackawaxen River begins its journey to the Delaware River in the Pocono Mountains of Northeastern Pennsylvania. Its watershed drains an area of about 600 square miles. It joins the Delaware at the town of Lackawaxen, just north of the historic Delaware Aqueduct. As a recreational resource, the Lackawaxen is popular among canoeists and trout fishermen.

Author Zane Grey, who for many years lived at the confluence of the Lackawaxen and Delaware, provided a perhaps tongue-in-cheek description of the beautiful Lackawaxen in his book *Tales of Freshwater Fishing*.

The Lackawaxen River Conservancy is comprised of local residents who are committed to protecting the river, its wildlife, watershed, and natural beauty. The organization promotes awareness of the ecological importance of the river's natural environment and partners with other organizations in regional affairs, legis-

lation, and planning issues that affect the river and watershed (www.lackawaxenriver.org).

Christina River

Near its mouth in Wilmington, Delaware, the Christina River forms the city's harbor for traffic on the Delaware River. The Port of Wilmington at the confluence handles international cargo vessels coming to and from the Delaware Bay, Philadelphia, and the Atlantic Ocean. Visitor attractions at the Wilmington riverfront include Fort Christina, Riverfront Arts Center, a park and river walk, and a replica of the fifteenth-century sailing ship *Kalmar Nyckel*.

The Christina River watershed is part of the Delaware River Basin. Tributaries of the thirty-five-mile-long river include the White Clay, Red Clay, and Brandywine Creeks. The Christina begins in Maryland and enters Delaware west of Newark after flowing through parts of Pennsylvania, then into the Delaware River at downtown Wilmington. The river includes extensive tidal freshwater wetlands, and most of its watershed is in New Castle County, Delaware (www.delawarewatersheds.org/piedmont/christina-river).

Raccoon Creek

This rusting but highly functional drawbridge over Raccoon Creek at Bridgeport, New Jersey, allows a free flow of traffic on Route 130.

A drawbridge over Raccoon Creek at Bridgeport opens for marine traffic near the point where the creek flows into the Delaware River.

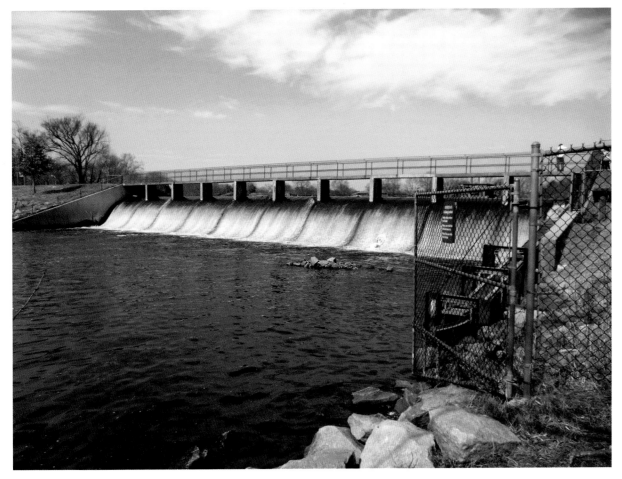

Silver Lake Reservoir flows over this dam into the St. Jones River at Dover, Delaware.

A small boat is chained up along the peaceful Rancocas Creek at Delanco, New Jersey, c. 1971.

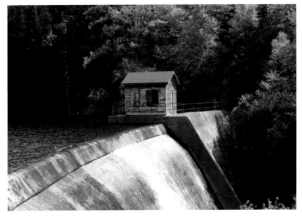

Ingersoll Dam in Harmony Township near Stewartsville, New Jersey, forms the Merrill Creek Reservoir. The creek flows into the Pohatcong Creek, a tributary of the Delaware River. The dam, c. 1972 in this photo, was later replaced with a more modern structure.

Raccoon Creek empties into the Delaware River at Bridgeport, New Jersey, just south of the Commodore Barry Bridge. In the 1600s, Swedish settlers from the colony of New Sweden traveled upstream along the creek to settle the communities of Bridgeport, once called New Stockholm, and Swedesboro. The creek that begins in Glassboro is twenty-three miles long. The Raccoon Creek Wildlife Management Area is easily accessible. The marshlands around the creek are habitat for wading birds, shore birds, ducks, and other waterfowl.

Tips for Photographers

What rule says you have to get the entire ship in the photo? A portion of a large object with an interesting background can make a pleasing composition.

Landscape photography is one of the most popular areas that photographers pursue, especially in the early stages of their work. Some of the most beautiful images embedded in our collective memory are landscapes, and many of those are of rivers. Rivers are popular subjects because they are everywhere. Finding access points from which to photograph rivers near you is probably easy. Drive a mile or two and you're there. Everyone has a river nearby because rivers were the backbone of early American transportation.

Equipment

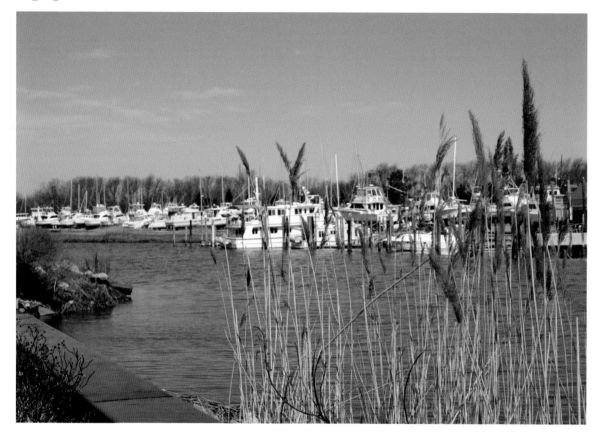

Sometimes it helps to accentuate a foreground object, such as these tall plants that might otherwise obstruct your photo.

You don't always want to take photos of signs, but doing so provides a good record of the place you're photographing, and can add interest if placed artistically in your composition.

What equipment do you need to take wonderful images of your favorite river or other landscape scene? First, you need a digital camera. Does it need to be a digital single lens reflex (DSLR)? Not necessarily. "Mirrorless" technology is becoming established, and most photographers agree that cell phone photography fits into the mirrorless category. As the name implies, mirrorless cameras don't have the mirror, prism, and accompanying noise associated with DSLR cameras, but many of them offer interchangeable lenses. While mirrorless cameras are surely the photographic tools of the future, most photographers today still find the DSLR to be the most flexible of digital cameras.

Buy the brand that feels comfortable to you, because there isn't a great deal of difference in the end results among the major brands. Go to your local camera store and handle the equipment. Ergonomics is important: How does the camera feel in your hands? Will you be comfortable with the location of the camera's controls? Another factor in determining which camera to buy might be lens availability. Maybe a friend or relative has a good collection of lenses that you can use if you buy a DSLR that accommodates those lenses. Many photographers have made their purchase decisions based on this alone.

How many megapixels do you need?

The great megapixel war isn't over yet. Camera manufacturers keep pumping up and advertising those numbers with exclamation points in such a way as to make consumers think the number of megapixels is the most important technical specification to consider. It's not. It would be difficult to find a DSLR camera today with less than sixteen megapixels. Cameras at the lowest end of today's megapixel landscape will produce brilliant photos capable of being printed to massive proportions.

What lenses do you need?

Lens selection is very important to most photographers, and decisions about these selections must be made carefully because lenses often cost more than the camera. Perhaps you already have a 35 mm (film) SLR camera and you've heard that your lenses will work with modern DSLRs of the same brand. This is generally true, but can be tricky. Often, in order to use an older lens on a modern camera you will give up some important feature. For example, with some older lenses you might have to focus manually instead of using the camera's autofocus capability. You might even have to do without in-camera exposure metering. Many photographers are comfortable with the trade-offs, but most would prefer to use all the capabilities of their cameras, which might require purchasing new lenses.

When photographing ships, like this replica of a 1638 sailing ship, zoom in on a detail such as the bow for added scale and perspective.

One of the biggest misconceptions about lenses is the idea that "more is better" when it comes to how much light a lens will allow to reach the camera's sensor. Typically, the larger the aperture, the more light the lens will transmit. The numerical system by which apertures are measured—the lower the number, the larger the lens aperture—is confusing to many photographers. An f1.8 lens, for example, will transmit more light than an f2.8 lens. There is a trend toward massive, light-gathering lenses (referred to as "fast" in the industry). They are massive because the more light a lens will transmit, the more glass is necessary, and that translates into size and weight. Fast lenses are necessary if you plan to shoot in dark venues such as concerts or other entertainment events, night street scenes,

Dilapidated and derelict objects can spark as much interest as the new and beautiful. Beat-up old boats have a story to tell, even if we can only imagine those stories.

If you have a friend with you, by all means include him or her in a photo or two. It might turn into something you'll be proud to show others (and so will he). This is Ken Yavit, one of my proofreaders.

sports, etc. But this discussion is about shooting landscapes in bright sunlight, so fast lenses are not necessary. Don't ever fall for the line that faster is better. Often, the opposite is true—lenses with smaller maximum apertures can produce extremely good quality images given enough light. A lens manufacturer might sacrifice image quality to make a fast lens.

Most modern DSLRs come in some sort of kit, and the lenses are often referred to as "kit" lenses. Some photographers prefer to scrap the kit lens in favor of fast lenses or lenses that have greater zoom range, wider angles, or greater telephoto capability. Many kits include two lenses so photographers will have extended shooting range right out of the box. If your kit comes with only one lens, it will likely be an 18–55 millimeter zoom, and it will not be a fast lens. Maximum aperture ranges for kit lenses will generally be about f3.5 at the wide-angle end to f5.6 at the longer (55mm) end.

The 18–55mm kit lens is probably all the lens you need to take great photos of rivers. You need a reasonably wide angle in order to get large portions of the river's beauty in the photo. The angle of coverage at 18 mm in most modern DSLRs is seventy-six degrees. This is adequate coverage for most river scenes, and the maximum angle used for the photos in this book. In addition, because you will be shooting in bright sunlight, a fast lens is not necessary. Think in terms of smaller apertures instead of larger ones because smaller apertures increase your depth of field and overall sharpness.

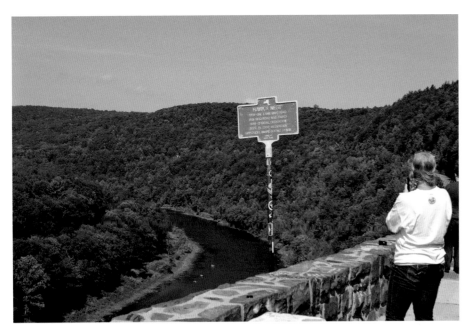

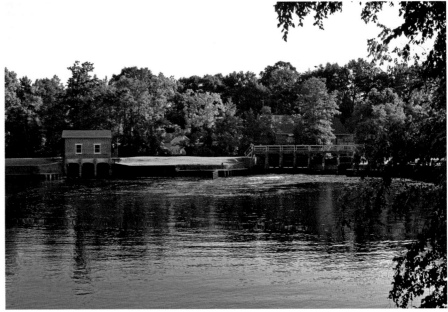

Including people in your photos adds scale and perspective that might otherwise be lost. The woman in this photo, compared to the people barely visible in the kayaks on the river, shows just how high above the river we were.

Including natural greenery such as tree branches on the sides or top of your photos is called framing and has been a standard composition tool ever since photography was invented.

Good support is essential

A tripod is a must for good landscape photography. Most photographers have a steady enough hand to shoot at fast shutter speeds without a tripod, but the extra support it affords is well worth the effort required to transport and set it up on location. Some digital cameras have vibration reduction or image stabilization features that eliminate some of the camera-motion blur associated with hand-held

photos, but this is not a substitute for a solid camera support. If you choose to use a tripod for your landscape photos, consult your camera's user manual to see if you should switch off the electronic image stabilizer.

Don't let an unsightly object like a handrail take away from the beauty of your photo. Embrace it as a part of the photo by using a wide-angle lens to alter its perspective.

Lens accessories

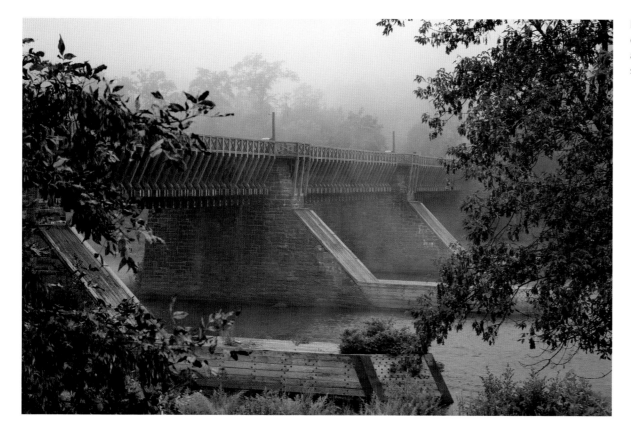

Don't let a little fog deter you. I took this photo early in the morning, then came back in the afternoon for a daylight shot, but liked the foggy shots better.

A good circular polarizing filter is a handy accessory for landscape photographers. It can turn drab colors into vibrant, deeply saturated tones. Because of the way your camera's digital sensor reacts to light, make sure your polarizing filter has the circular designation rather than linear. Also, when using a circular polarizer for landscape photography, always use the camera's daylight white balance setting. Your camera probably defaults to automatic white balance, which is great for most color shooting, but might negate the effects of the circular polarizer.

Most photographers like to use an ultraviolet or skylight filter simply to protect the lens. This is a smart idea if the filter you buy is a good one, such as one that has multicoating. Avoid cheap filters, as they can have a negative impact on your images, and don't use a protective filter in combination with a polarizer. A lens hood is another important accessory for outdoor photography. The hood prevents stray light rays from entering your camera and causing flare patterns. Lens hoods generally do not come with a camera's kit lens, but can be purchased separately. The lens hood should be removed when you use the on-camera flash, as the hood will cast a shadow on your subject.

What is ISO and where should you set it?

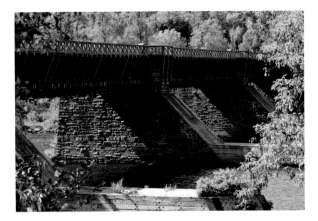

The afternoon shot isn't nearly as interesting as the early morning foggy shot.

ISO is an abbreviation for International Organization of Standardization. In photography it relates to sensitivity to light, with the lower the ISO setting the more light required to take a photo, and vice versa. In digital photography, the user sets the ISO based on the lighting conditions. It can be changed at any time during the photography session if the light changes, or if fast action would require faster shutter speeds than what are attainable with lower ISO settings.

The higher the ISO, the more light is transmitted to the sensor of digital cameras, but higher ISOs involve trade-offs. In the digital world, high ISOs result in what is called noise, which is simply annoying artifacts in the image that detract from the image quality and make it nearly impossible to make large prints. In landscape photography, the lower the ISO the better. You will typically use ISO 100 or 200 for your bright-sun, blue-sky landscape images, and the quality will be superb compared to a higher ISO.

Finding access points

The main rule to remember is don't trespass on private property. I may have trespassed a time or two in my zeal to capture the images in my books, but I never did so knowingly. Often, what appears to be a public road is actually on private property, but you don't know that because a "private property" sign may have been removed. In this case, you'll end up in someone's cornfield or perhaps violate a railroad's right-of-way.

When I first started shooting rivers, I used my computer map program to locate what looked like access points. My success rate using maps was only about fifty percent because so many of those mapped points were on private property. Whenever possible, ask the owner of the property if you can shoot there. Most will say yes if you're polite and respectful.

Using maps was good, but I needed to increase my success rate. So I started using Google Earth, a satellite-imaging program. I use a dual-monitor setup with my computer system, so I began opening my map program on one monitor and the corresponding satellite image on the other. Zooming in on a satellite image produces a reasonable basis for deciding whether the road ends at the river on private or public land. This method increased my success rate to about seventy-five percent. Your results may vary.

Thanks for reading—happy shooting.

Bibliography

Books

Francis, Austin M. *Catskill Rivers: Birthplace of American Fly Fishing*. Guilford, Connecticut: The Lyons Press, 1983.

Grey, Zane. *Tales of Freshwater Fishing*. Lanham, Maryland: The Derrydale Press, 1928.

Howard, Michael and Maureen. *Benjamin Franklin Bridge, The (Images of America)*. Charleston, South Carolina: Arcadia Publishing, 2009.

Woodlief, Ann. *In River Time: The Way of the James*. Chapel Hill, North Carolina: Algonquin Books of Chapel Hill, 1985.

Web

Borough of National Park.
 http://www.nationalparknj.com/.
Bristol Cultural and Historical Foundation.
 http://www.bristolhistory.org.
City of Chester, Pennsylvania.
 http://www.chestercity.com.
City of Easton, Pennsylvania.
 http://www.easton-pa.gov.
City of Gloucester City.
 http://www.cityofgloucester.org.
City of Port Jervis, New York.
 http://www.portjervisny.org/about/history.
City of Wilmington, Delaware.
 http://www.ci.wilmington.de.us/residents/cityinfo.
Chesapeake and Delaware Canal.
 http://www.pennways.com/CD_Canal.html.

Delaware River Basin Commission.
 http://www.nj.gov/drbc.
Delaware River Basin Source Water Collaborative.
 www.delawarebasindrinkingwater.org.
Delaware River Greenway Partnership.
 http://www.delrivgreenway.org
Delaware River Mill Society.
 http://www.prallsvillemills.org/history.
Delaware Riverkeeper.
 http://delawareriverkeeper.org/delaware-river/index.asp.
Delmarva Beach Guide.
 http://www.delmarvabeachguide.com/lewes.
Encyclopaedia Britannica.
 http://www.britannica.com/place/Delaware-Bay.
Friends of the Upper Delaware River.
 http://www.fudr.org/
Friends of the Wissahickon.
 http://www.fow.org.
Game & Fish.
 http://www.gameandfishmag.com/fishing/fishing_pa_0308_01/.
Historic Smithville Park.
 http://www.co.burlington.nj.us/948/Historic-Smithville-Park.
Lackawaxen River Conservancy.
 http://lackawaxenriver.org.
Lehigh Valley Water Suppliers, Inc.
 http://www.lvwater.org.
Lewes, Delaware.
 http://www.lewes.com/.
Lewes Chamber of Commerce.
 http://www.leweschamber.com/.

Lumberton Township, New Jersey.
 http://www.lumbertontwp.com/community/our-history/.
Nature Conservancy, The.
 http://www.nature.org/ourinitiatives/regions/northamerica/unitedstates/newjersey/placesweprotect/delaware-river-basin.xml.
New Jersey Department of Environmental Protection.
 http://www.state.nj.us/dep/parksandforests/parks/fortmott.html.
Partnership for the Delaware Estuary.
 http://www.delawareestuary.org.
Rancocas Conservancy.
 www.rancocasconservancy.org.
Upper Delaware Scenic and Recreational River National Park Service.
 http://www.nps.gov/upde/learn/nature/index.htm.
Visit Delaware.
 http://www.visitdelaware.com/beaches/lewes/.
Visit Philadelphia.
 http://www.visitphilly.com/.
Washington Crossing Historic Park.
Washington Crossing State Park.
 http://www.state.nj.us/dep/parksandforests/parks/washcros.html.